Big School of
Drawing
Workbook

Exercises and step-by-step drawing
lessons for the beginning artist

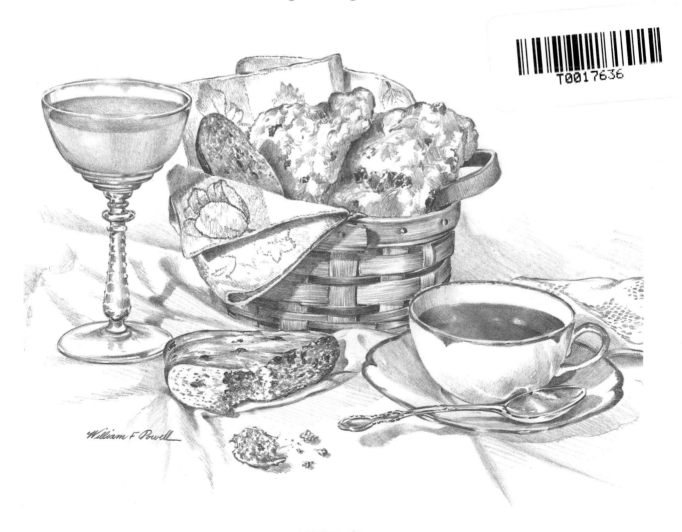

William F. Powell

Walter Foster

Contents

Introduction . 3

Basics . 4
Hatching . 4
Drawing with a Sharp Point 6
Drawing with a Blunt Point 7
Basic Shapes . 8
Warming Up . 10

Flowers . 12
Drawing Exercises
Basic Flower Shapes 12
Beginning
Simple Flowers . 14
Morning Glory . 14
Gardenia . 15
Tulips . 16
Poppy . 18
Pansy . 19
Regal Lily . 20
Floral Bouquet . 22
Columbine . 24
Peony . 26
Advanced
Thistle . 28
Gladiolus . 30

Landscapes . 32
Drawing Exercises
Sketching Leaves . 32
Rocks . 34
Car Detail . 36
Beginning
Old Tree . 38
Mountains . 40
Monument Valley . 42
Deserts . 44
Mill by the Stream . 46
Introducing Perspective 48
Advanced
Capturing Vacation Scenes 50
New York . 52

Animals . 54
Drawing Exercises
Basic Shapes . 54
Drawing Accurately 55
Creating Animal Textures 56

Beginning
Rabbits . 58
Cats . 60
Sparrow . 62
Kangaroo . 64
Giraffe . 66
Baby Monkey . 68
Golden Retriever . 70
Horse Portrait . 72
Advanced
Iguana . 74
Gorilla . 76

People . 78
Drawing Exercises
Eyes . 78
Nose & Ears . 80
Lips . 82
Studying Adult Proportions 84
Beginning
Approaching a Profile View 86
Capturing a Likeness 88
Working with Lighting 90
Drawing from Life . 92
Advanced
Rendering a Baby . 94
Developing Hair . 96
Creating Facial Hair 98

Still Life . 100
Drawing Exercises
Rose with Waterdrops 100
Depicting Textures . 102
Beginning
Floral Arrangement 104
Liquid & Glass . 106
Advanced
Sunday Breakfast . 108
Reflections & Lace . 110

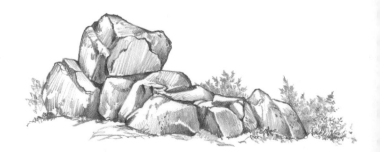

Introduction

From basic drawing exercises to finished artwork, welcome to Big School of Drawing Workbook!

This exercise book guides you step by step through a range of drawing techniques and subjects. After walking you through simple strokes and warm-ups, the book presents five chapters covering five of the most common subject categories, from floral arrangements and outdoor scenes to animals and people. Each chapter is broken down into three sections: *Drawing Exercises* for simple concepts, *Beginning* to build confidence, and *Advanced* for rendering more involved, finished pieces. Along the way, you'll find room to draw right in the book so you can practice as you learn.

Surely you've heard the phrase "practice makes perfect." This statement rings true for drawing as much as any other skill. If you follow the exercises and projects in this book, you'll see great improvement in your speed and accuracy. And one way to make sure you continue practicing is to choose subjects that are close to your heart. You will naturally have the care and patience to work on the drawing until it is finished. For example, when drawing portraits, choose your beloved pets or family members. When drawing landscapes, choose scenes full of memories. Let your hobbies, interests, and personal ambitions guide you and keep up your level of inspiration.

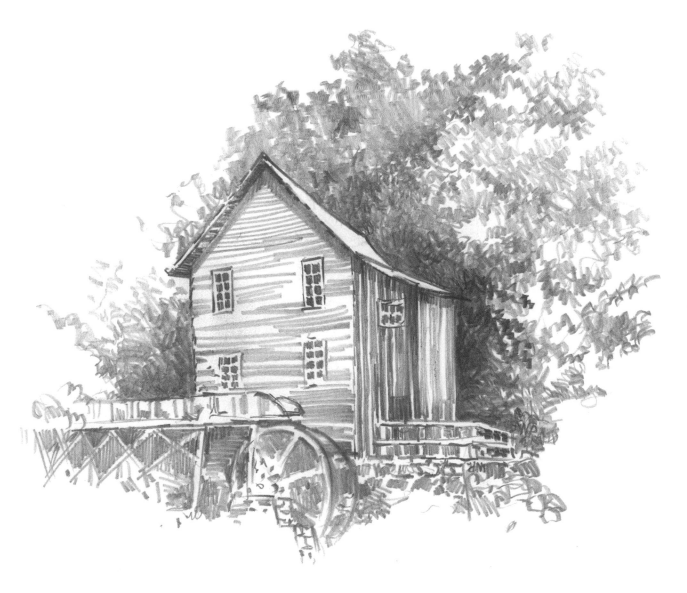

Basics
Hatching

By studying the basic pencil techniques below, you can learn to render everything from a smooth complexion and straight hair to shadowed features and simple backgrounds. Whatever techniques you use, though, remember to shade evenly. Shading in a mechanical, side-to-side direction, with each stroke ending below the last, can create unwanted bands of tone throughout the shaded area. Instead try shading evenly, in a back-and-forth motion over the same area, varying the spot where the pencil point changes direction.

Hatching This basic method of shading involves filling an area with a series of parallel strokes. The closer the strokes, the darker the tone will be.

Crosshatching For darker shading, place layers of parallel strokes on top of one another at varying angles. Again, make darker values by placing the strokes closer together.

Gradating To create graduated values (from dark to light), apply heavy pressure with the side of your pencil, gradually lightening the pressure as you stroke.

Shading Darkly By applying heavy pressure to the pencil, you can create dark, linear areas of shading.

Shading with Texture For a mottled texture, use the side of the pencil tip to apply small, uneven strokes.

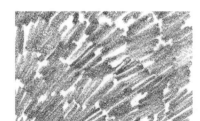

Blending To smooth out the transitions between strokes, gently rub the lines with a tortillon or tissue.

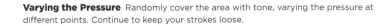

When you use painterly strokes, your drawing will take on a new dimension. Think of your pencil as a brush and allow yourself to put more of your arm into the stroke. To create this effect, try using the underhand position, holding your pencil between your thumb and forefinger and using the side of the pencil. If you rotate the pencil in your hand every few strokes, you will not have to sharpen it as frequently. The larger the lead, the wider the stroke will be. The softer the lead, the more painterly an effect you will have. These examples were all made on smooth paper with a 6B pencil, but you can experiment with rough papers for more broken effects.

Starting Simply First experiment with vertical, horizontal, and curved strokes. Keep the strokes close together and begin with heavy pressure. Then lighten the pressure with each stroke.

Varying the Pressure Randomly cover the area with tone, varying the pressure at different points. Continue to keep your strokes loose.

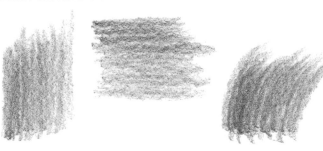

Using Smaller Strokes Make small circles for the first example. This is reminiscent of leathery animal skin. For the second example (below right), use short, alternating strokes of heavy and light pressure to create a pattern that is similar to stone or brick.

Loosening Up Use long vertical strokes, varying the pressure for each stroke until you start to see long grass (below left). Then use somewhat looser movements that could be used for water (below right). First create short spiral movements with your arm (above). Then use a wavy movement, varying the pressure (below).

Drawing with a Sharp Point

First draw a series of parallel lines. Try them vertically; then angle them. Make some of them curved, trying both short and long strokes. Then try some wavy lines at an angle and some with short, vertical strokes. Try making a spiral and then grouping short, curved lines together. Then practice varying the weight of the line as you draw. Os, Vs, and Us are some of the most common alphabet shapes used in drawing.

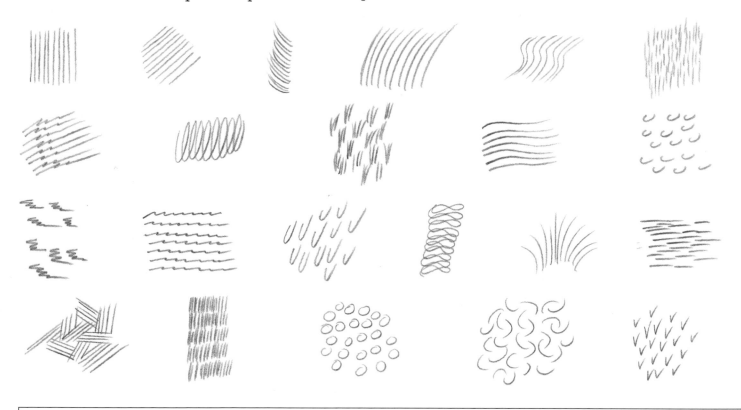

Drawing with a Blunt Point

It is helpful to take the same exercises and try them with a blunt point. Even if you use the same hand positions and strokes, the results will be different when you switch pencils. Take a look at these examples. The same shapes were drawn with both pencils, but the blunt pencil produced different images. You can create a blunt point by rubbing the tip of the pencil on a sandpaper block or on a rough piece of paper.

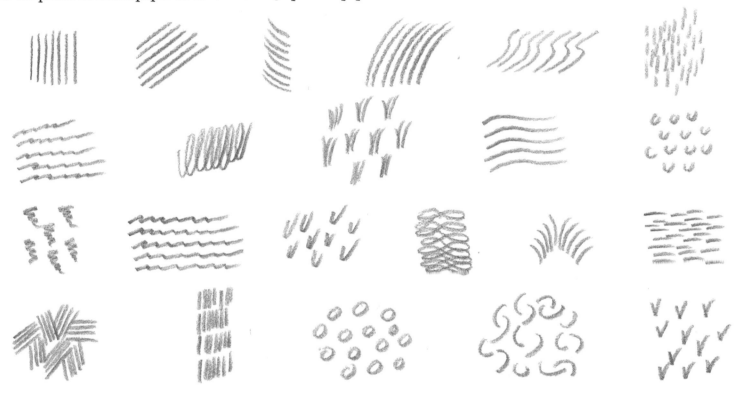

Basic Shapes

Combining Shapes Here is an example of beginning a drawing with basic shapes. Start by drawing each line of action; then build up the shapes of the dog and the chick with simple ovals, circles, rectangles, and triangles.

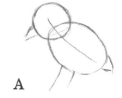

A

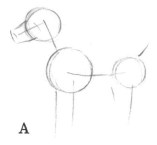

A

Building Form Once you establish the shapes, it is easy to build up the forms with cylinders, spheres, and cones. Notice that the subjects are now beginning to show some depth and dimension.

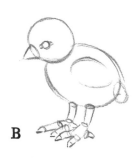

B

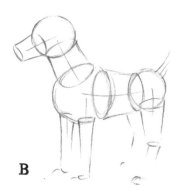

B

Drawing Through "Drawing through" refers to drawing the complete forms, including the lines that will eventually be hidden from sight. Here when the forms were drawn, the back side of the dog and chick were indicated. Even though you can't see that side in the finished drawing, the subject should appear three-dimensional. To finish the drawing, simply refine the outlines and add a little fluffy texture to the downy chick.

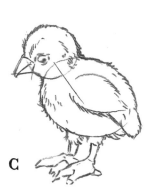

C

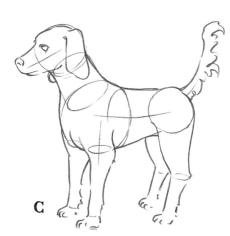

C

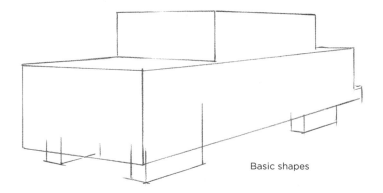

Basic shapes

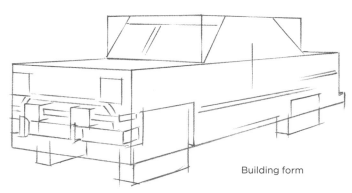

Building form

Step 1 Even a complex form such as this '51 Ford is easy to draw if you begin with the most basic shapes you see. At this stage, ignore all the details and draw only squares and rectangles. You will erase these guidelines later, so draw lightly and freely.

Step 2 Using those basic shapes as a guide, add squares and rectangles for the headlights, bumper, and grille. Start to develop the form of the windshield with angled lines, and then sketch in a few straight lines to place the door handle and the side detail.

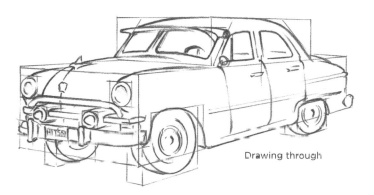

Drawing through

Step 3 Once you have all the major shapes and forms established, begin rounding the lines and refining the details to conform to the car's design. As a final step, clean up the drawing by erasing the extraneous lines.

Warming Up

Drawing is about observation. If you can look at your subject and really see what is in front of you, you're halfway there already—the rest is technique and practice. Warm up by sketching a few basic three-dimensional forms—spheres, cylinders, cones, and cubes. Gather some objects from around your home to use as references, or study the examples here. And by the way, feel free to put a translucent piece of paper over these drawings and trace them. It's not cheating—it's good practice.

Starting Out Loosely

Begin by holding the pencil loosely in the underhand position. Then, using your whole arm, not just your wrist, make a series of loose circular strokes, just to get the feel of the pencil and to free your arm. (If you use only your wrist and hand, your sketches may appear stiff or forced.) Practice drawing freely by moving your shoulder and arm to make loose, random strokes on a piece of scrap paper. Keep your grip relaxed so your hand does not get tired or cramped, and make your lines bold and smooth. Now start doodling—scribble a bunch of loose shapes without worrying about drawing perfect lines. You can always refine them later.

Roughing In Lightly sketch the general shapes of a variety of objects, roughly indicating the shaded areas. Also look at the shape of the shadow the object throws, and use your darkest shading here. Experiment by using different types of pencils (H, HB, 2B), changing the pressure on your pencil, and see what different lines you create.

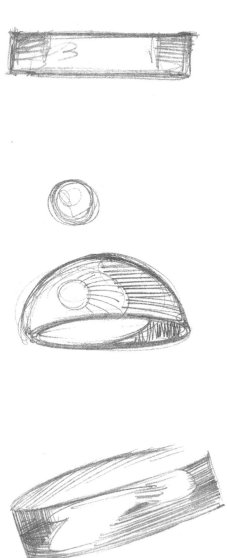

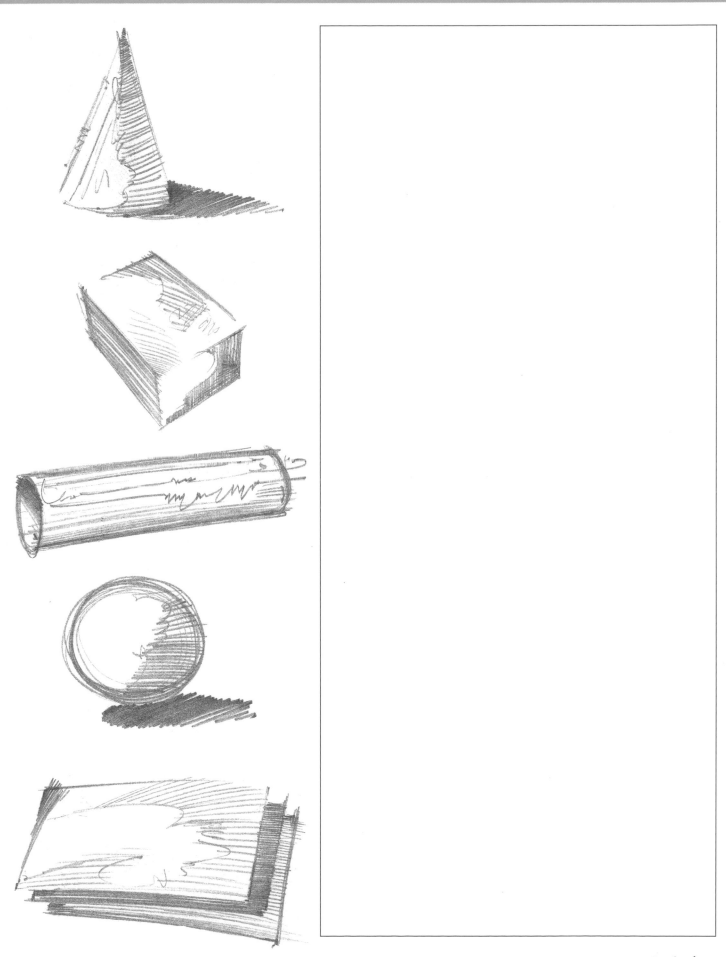

Flowers
Basic Flower Shapes

As you can see, even the most complicated flowers can be developed from simple shapes. Select a flower you wish to draw and study it closely, looking for its overall shape. Sketch the outline of this shape, and begin to look for the other shapes within the flower. Block in the smaller shapes that make up details, such as petals or leaves. Once you've completed this, smooth out your lines and begin the shading process.

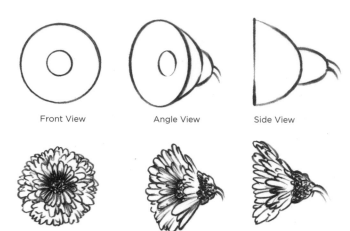

Front View Angle View Side View

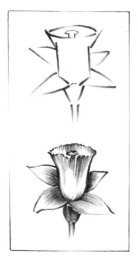

With an HB pencil, sketch the cup-like shape of the flower first; then place the petals and stem, as shown above. Begin developing the form with shading.

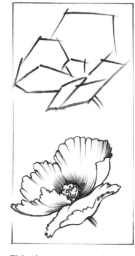

This three-quarter view may seem more difficult to draw, but you can still bring out its basic shapes if you study it carefully. Begin each petal with short lines drawn at the proper angles.

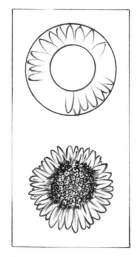

Circles enable you to draw round flowers. Set the size with a large circle, and place a smaller one inside. Using them as a guide, shade details.

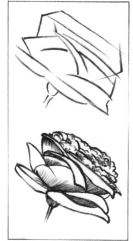

Drawing flowers with many overlapping petals is more involved, once the basic shapes are sketched in, the details can easily be drawn.

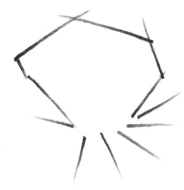

Step 1 Block the basic shape of the flower using straight lines.

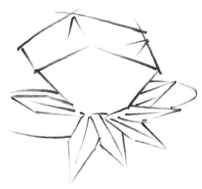

Step 2 Now sketch in the smaller shapes, including the leaves and outer layer of petals.

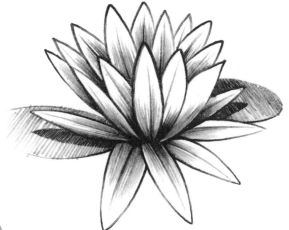

Step 5 Add shading with hatched lines that follow the length of the petals, blending behind each overlap. Build up the darkest tones within the cast shadows.

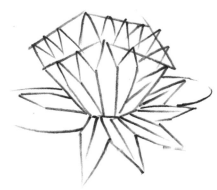

Step 3 Continue blocking in to create rows of overlapping petals.

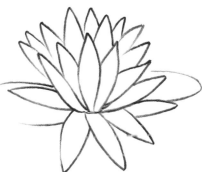

Step 4 Clean up the sketch, rounding out and erasing lines as needed.

Simple Flowers
Morning Glory

This morning glory and gardenia are great flowers for learning a few simple shading techniques called "hatching" and "crosshatching." Hatch strokes are parallel diagonal lines; place them close together for dark shadows, and space them farther apart for lighter values. Cross-hatch strokes are made by first drawing hatch strokes and then overlapping them with hatch strokes that are angled in the opposite direction.

 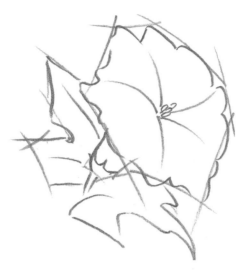 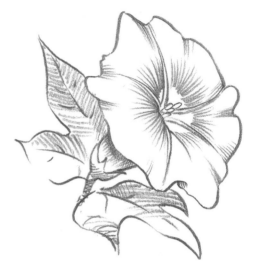

Step 1 Look carefully at the overall shape of a morning glory and lightly sketch a polygon with the point of an HB pencil. From this three-quarter view, you can see the veins that radiate from the center, so sketch in five curved lines to place them. Then roughly outline the leaves and the flower base.

Step 2 Next draw the curved outlines of the flower and leaves, using the guidelines for placement. You can also change the pressure of the pencil on the paper to vary the line width, giving it a little personality. Then add the stamens in the center.

Step 3 Now you are ready to add the shading. With the rounded point and side of an HB pencil, add a series of hatching strokes, following the shape, curve, and direction of the surfaces of the flower and leaves. For the areas more in shadow, make darker strokes placed closer together, using the point of a soft 2B pencil.

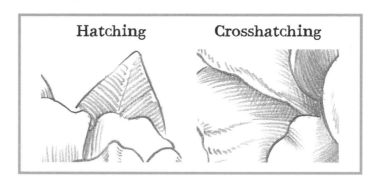

| Hatching | Crosshatching |

Gardenia

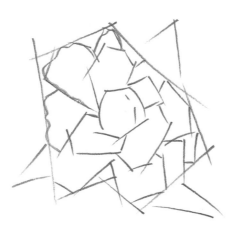

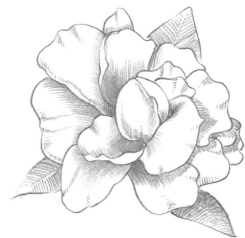

Step 1 The gardenia is a little more complicated to draw than the morning glory, but you can still start the same way. With straight lines, block in an irregular polygon for the overall flower shape and add partial triangles for leaves. Then determine the basic shape of each petal and begin sketching in each, starting at the center of the gardenia.

Step 2 As you draw each of the petal shapes, pay particular attention to where they overlap and to their proportions, or their size relationships—how big each is compared with the others and compared with the flower as a whole. Accurately reproducing the pattern of the petals is one of the most important elements of drawing a flower. Once all the shapes are laid in, refine their outlines.

Step 3 Again, using the side and blunt point of an HB pencil, shade the petals and the leaves, making your strokes follow the direction of the curves. Lift the pencil at the end of each petal stroke so the line tapers and lightens, and deepen the shadows with overlapping strokes in the opposite direction (called "crosshatching") with the point of a 2B pencil.

Tulips

There are several classes of tulips with differently shaped flowers. The one below, known as a parrot tulip, has less of a cup than the tulip to the right and is more complex to draw. Use the layout steps shown here before drawing the details.

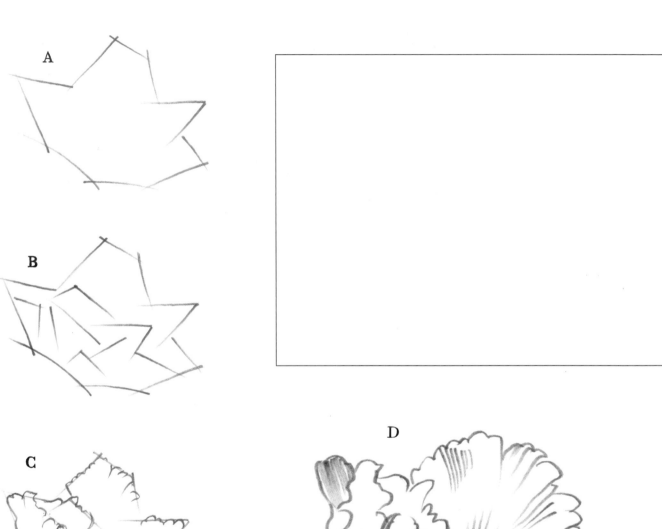

A

B

C

D

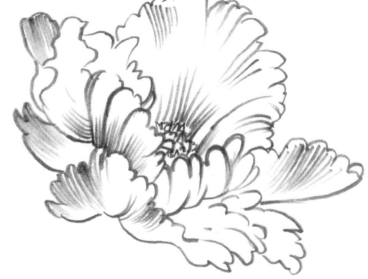

Use straight lines to indicate the flower's main shape (A). Continue blocking in the edges of the petals within the main shape (B). Refine the shapes by indicating the curly edges of the petals (C). Erase any guidelines you no longer need. Finish by using tapered strokes to hatch in simple shadows (D).

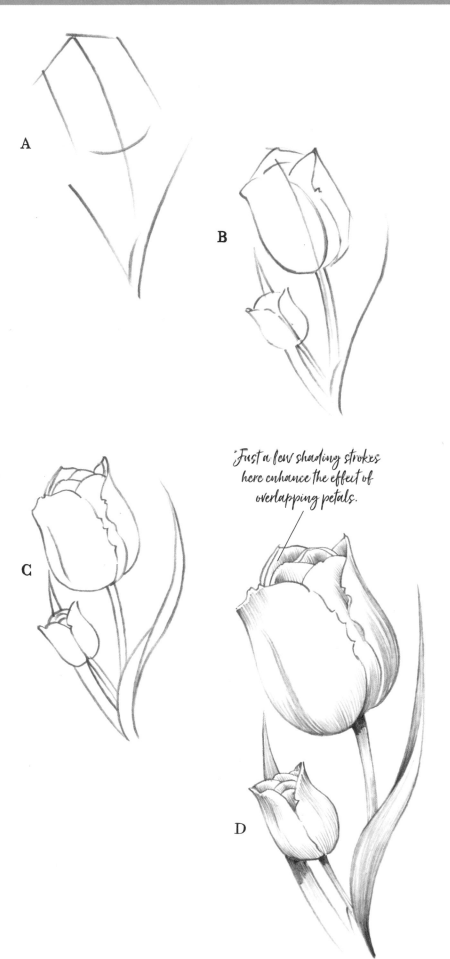

A

B

C

D

Look for the rhythm of line in this next tulip. Begin with simple lines to set the basic direction of the leaves and stem (A). Start refining the outlines, building the petals, stems, and leaves over the guidelines (B). Clean up the drawing by erasing the original guidelines (C). Add detail and shading to the flower with smooth hatching that follows the forms of the petals and leaves (D). Just a few strokes of shading can create the illusion of overlapping petals.

Just a few shading strokes here enhance the effect of overlapping petals.

Poppy

The beautiful California poppy grows in a variety of colors from deep orange to pale yellow. The blossoms are paper-like and delicate. The flower spreads about 2 inches wide. Use the following demonstrations to practice blocking in a bud and then to render a more involved leaf-and-flower composition.

A

A

B

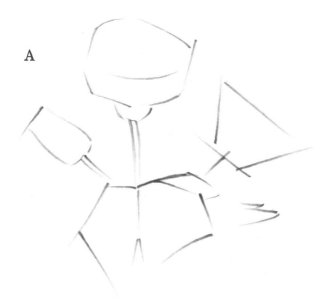

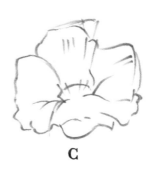

C

B

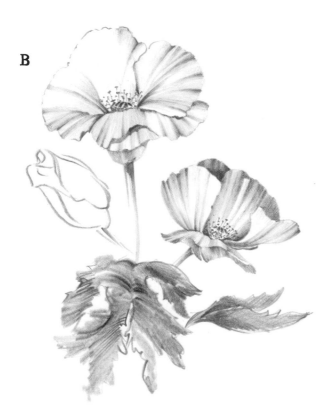

Pansy

Pansies grow in many color combinations. Sometimes these combinations resemble faces, almost having expressions. When drawing the pansy, use the steps to overlap the petals so each one slightly covers another near the edges. Notice how the dark shading near the center gives the illusion of the flower having two colors, as well as three-dimensional form.

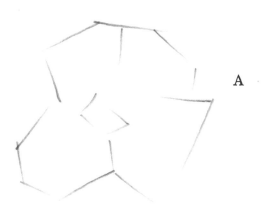

A

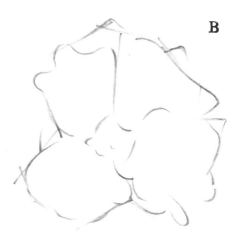

B

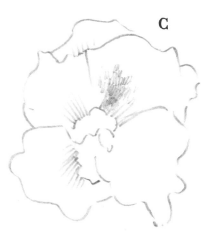

C

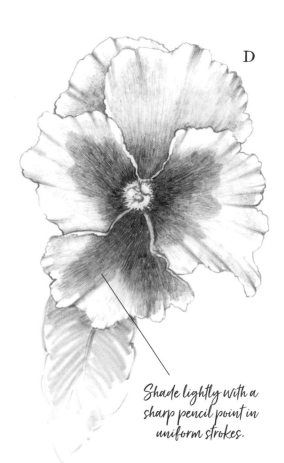

D

Shade lightly with a sharp pencil point in uniform strokes.

Regal Lily

Lilies are very fragrant, and the plants can grow up to 8 feet tall. Their sturdy, gently curving petals and dramatic trumpet silhouettes make them fun drawing subjects. Use the steps below to develop the flower, which you can then develop into a full plant.

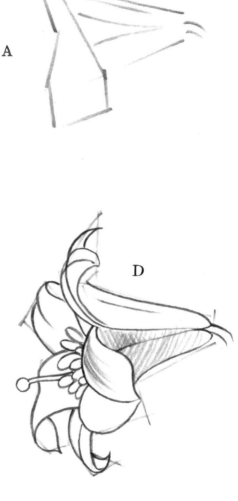

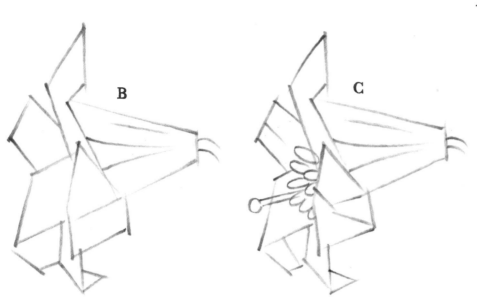

Use straight lines to block in the flower's profile (A) and the petals nearest to you (B). Now block in the remaining petals of the flower and the pistil and stamens of the flower's center (C). Using the rough lines as a guide, refine the outlines with smooth, curving strokes. Lightly crosshatch to begin developing form (D).

Lily Bud

Add closed (A) and partially open (B) buds to your lily plants for variety. Crosshatch along the petals to show form.

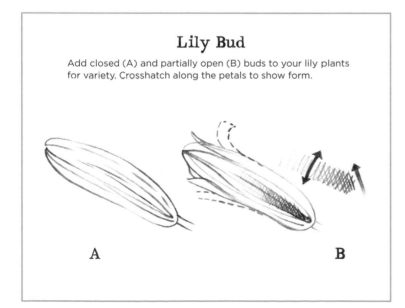

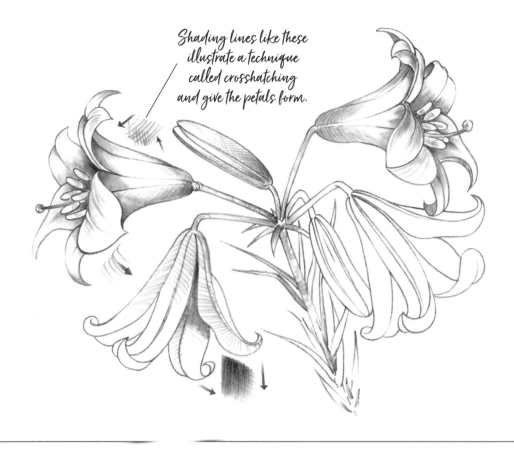

Shading lines like these illustrate a technique called crosshatching and give the petals form.

Floral Bouquet

If you look carefully, you will see that although the roses resemble one another, each one has unique features, just as people do. If you make sure your drawing reflects these differences, your roses won't look like carbon copies of one another.

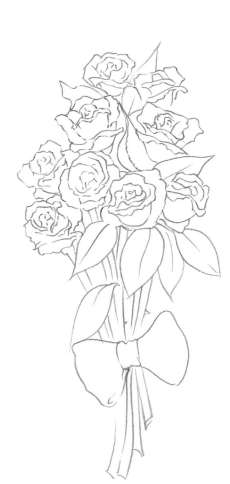

Step 1 Just as you did for single flowers, begin by drawing the basic shapes of the roses with an HB pencil. Block in only the outlines and a few major petal shapes, without getting involved in the details. Then sketch in the stems and the shape of the ribbon. These first lines are merely guidelines for developing the drawing, so keep the strokes simple and very light.

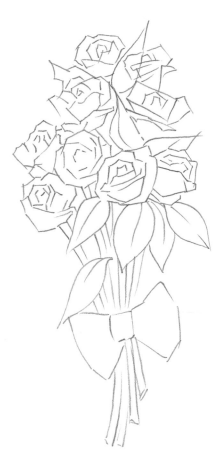

Step 2 Once you've established the general outlines, begin developing the secondary shapes of each flower—the curves and indentations of the petals. These are the elements that make each rose unique, so pay careful attention to the shapes at this stage of the drawing.

Step 3 Now begin to define the shapes more precisely, adding detail to the innermost petals, refining the stems, and developing the shape of the ribbon. Vary the thickness of each line to give the drawing more character and life. Don't shade at all in this step; you will want to make sure the drawing is accurate first.

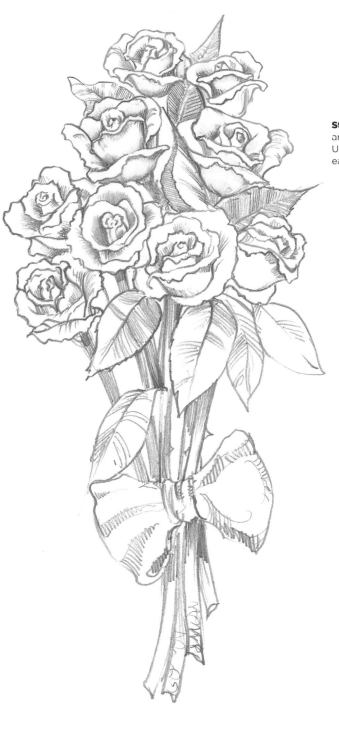

Step 4 Sometimes keeping the shading fairly minimal and light shows how effective simple drawing can be. Use hatched strokes and place only enough shading on each flower, leaf, and stem to give it some form.

Columbine

The columbine is an unusual but graceful flower with long protrusions known as spurs. These spurs are very important to butterflies and hummingbirds because each tip contains a drop of nectar.

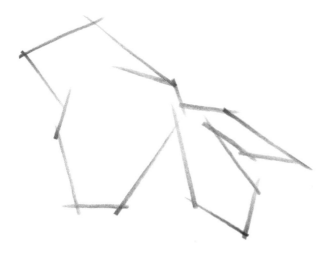

Step 1 Block in the flowers and leaves using straight lines that follow the angles of the edges. Work lightly at this point so you can erase your lines later if needed.

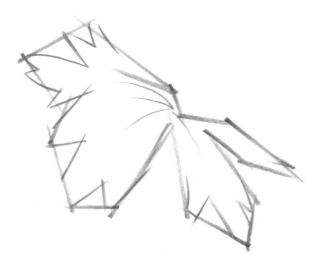

Step 2 Use the guidelines to work out the edges and interior lines. Add a few strokes to start indicating form.

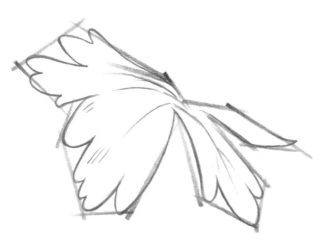

Step 3 Refine the outlines with curved strokes and begin shading.

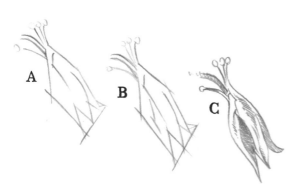

Step 4 Build up tone by stroking along the length of the stems and curving along the forms of your petals and leaves. Add cast shadows to suggest the direction of light falling on the plant.

Spurs

Peony

Peonies grow in single- and double-flowered varieties and make fine subjects for flower drawings. Begin by drawing and positioning the major flower parts (A), and then start shading the petals and surrounding leaves (B). Apply shading in earnest and establish the background pattern (C, D).

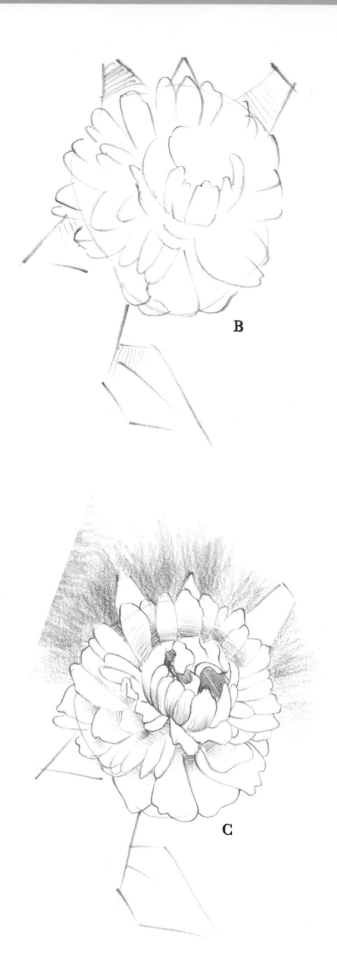

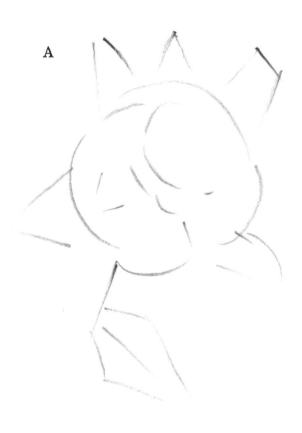

A

B

C

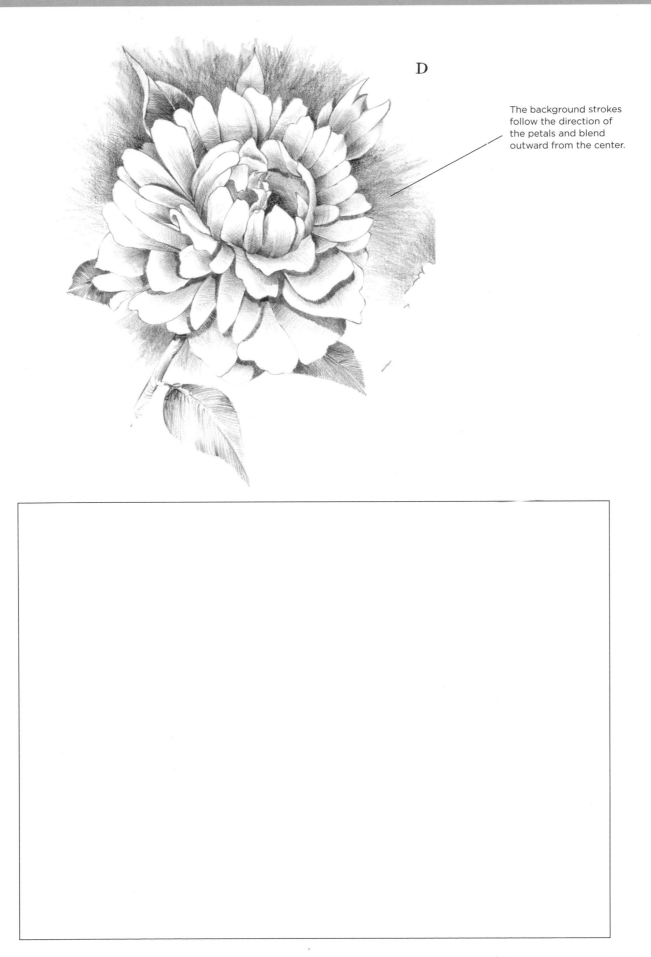

D

The background strokes follow the direction of the petals and blend outward from the center.

Thistle

Of the many thistle species, the one shown here is the *Cirsium muticum*. It's a popular, purple-flowered specimen that can be found in fields and low-lying pastures. The side of the flower is prickly, while the flower is soft and delicate, creating an interesting contrast.

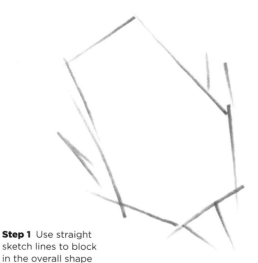

Step 1 Use straight sketch lines to block in the overall shape of the flower.

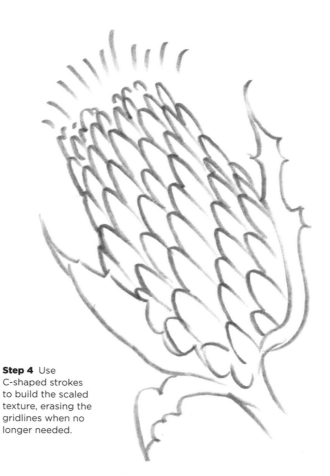

Step 2 Build the sepals with pointed edges and suggest the tuft along the top with short strokes.

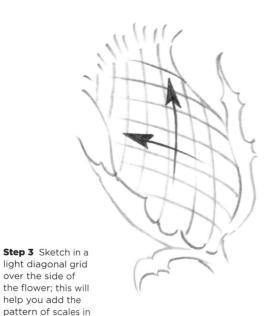

Step 3 Sketch in a light diagonal grid over the side of the flower; this will help you add the pattern of scales in the next step.

Step 4 Use C-shaped strokes to build the scaled texture, erasing the gridlines when no longer needed.

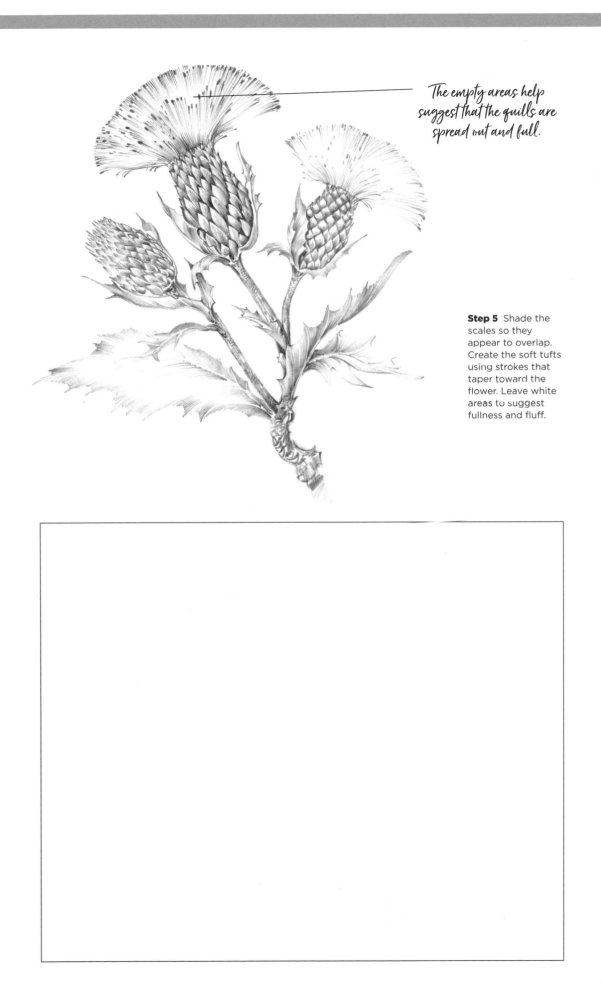

The empty areas help suggest that the quills are spread out and full.

Step 5 Shade the scales so they appear to overlap. Create the soft tufts using strokes that taper toward the flower. Leave white areas to suggest fullness and fluff.

Gladiolus

Gladiolus can grow to a height of 2 to 6 feet, and their flowers range from 2 to 6 inches across. Petals can be smooth, wavy, or ruffled.

Step 1 Use an HB pencil to block in the complex shape of this flower.

Step 2 Indicate the interior petals with more lines, sketching in strokes that follow the angles of the petals.

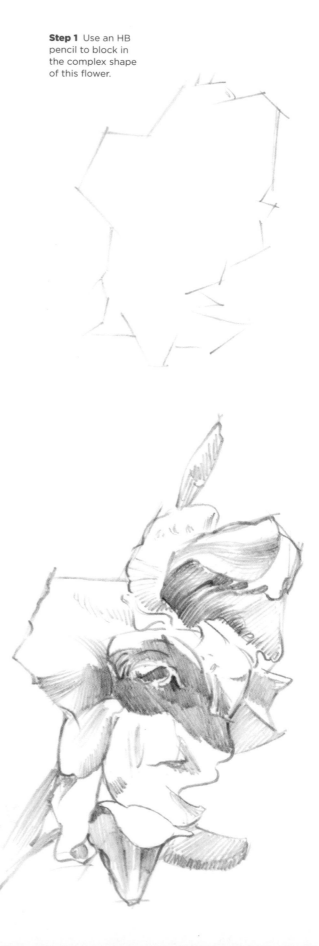

Step 3 Refine the outlines and begin shading with parallel lines that taper and curve to define the petal forms. Erase any sketch marks you no longer need.

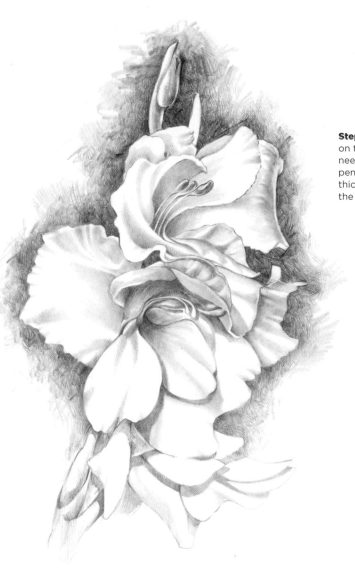

Step 4 Blend away your strokes to create soft blends on the petals, lifting out tone with an eraser where needed. Build the background with a flat sketching pencil, applying short strokes that vary in direction, thickness, and value. The darker background will help the flower "pop" against the paper.

Landscapes
Sketching leaves

Broad-leaved trees—such as beeches, maples, and some oaks—have broad, flat leaves, produce flowers, and shed leaves every fall (deciduous). Study the subtle variations of shapes shown in these examples. As you draw, notice the different techniques used for the leaves on each tree. First sketch the trunk, and then draw the general shape of the whole group of leaves before shading the foliage.

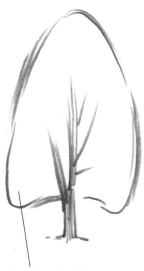

Use the side of the pencil lead for the basic layout sketches.

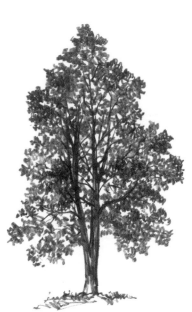

Alder

Variations of value create the thick, dense foliage of the red maple.

Red maple

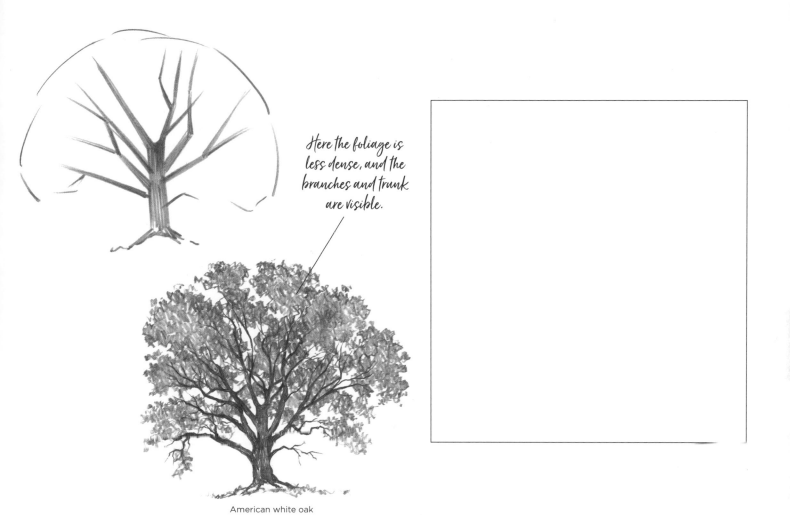

Here the foliage is less dense, and the branches and trunk are visible.

American white oak

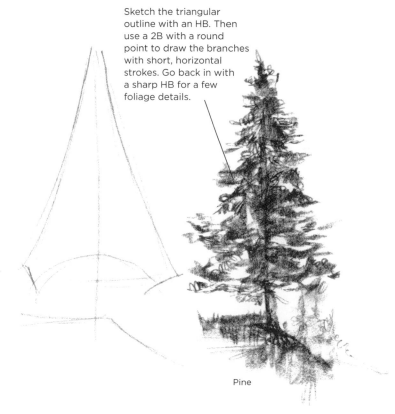

Sketch the triangular outline with an HB. Then use a 2B with a round point to draw the branches with short, horizontal strokes. Go back in with a sharp HB for a few foliage details.

Pine

Rocks

Because rocks come in many shapes and textures, the best approach is to closely observe the ones you're drawing.

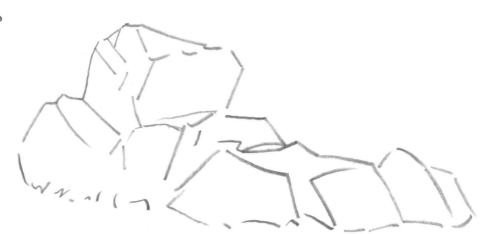

Step 1 To begin, lightly block in the basic shapes to establish the different planes.

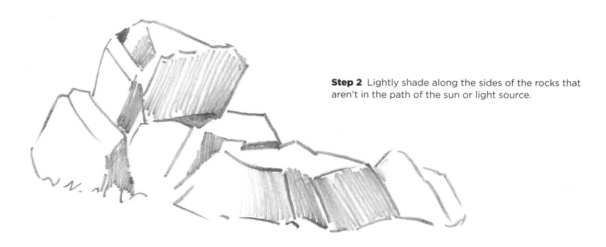

Step 2 Lightly shade along the sides of the rocks that aren't in the path of the sun or light source.

Step 3 Slowly develop more intricate details, such as grooves, cracks, and indentations. Use a sharp 2B pencil to fill in areas between the rocks and within the cracks.

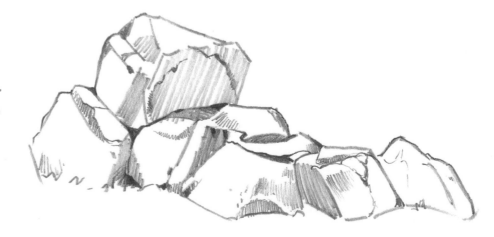

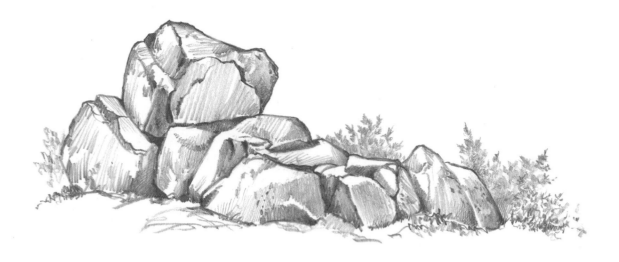

Step 4 Rock surfaces are generally uneven and bumpy. Try to create a variety of shading values on the rocks so they appear jagged. Hatch in various directions to follow the shapes of the rocks, and make the values darker in the deepest crevices, on sharp edges, and in the areas between rocks. With a few simple squiggles and scratches, suggest some ground and soft, lacy background foliage to give context to the final drawing.

Car Detail

Landscapes aren't limited to scenes from nature; cityscapes and street scenes count too! In the finished drawing at right, notice the use of one-point perspective; the road and all the horizontal lines of the buildings converge to one point in the distance on the horizon line (called the "vanishing point"). Before jumping into a complex cityscape, start small and draw elements within the scene first, such as this car. You'll notice that the lines of the car, like the road and buildings, point toward the vanishing point.

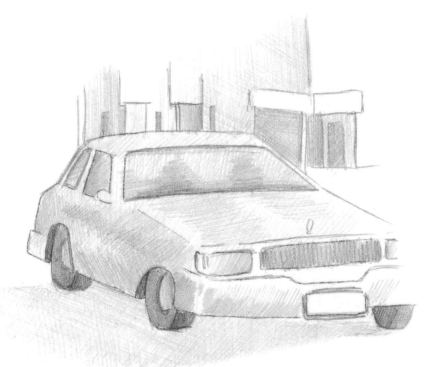

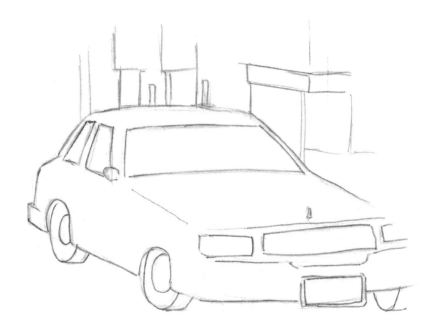

Step 1 Complete the full outline of the car, indicating every plane on the body and within the tires.

Step 2 Now begin shading with cross-hatching and pencils ranging from 2H to H. Keeping in mind the direction of light, shade the left side of the car. Shade heavily on the undersides of the tires, and use horizontal strokes to indicate the car passengers.

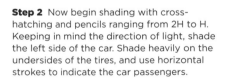

Step 3 Intensify the middle and dark values to create dynamic contrasts. Use pencils ranging from HB to 2B with crosshatching to add tone, using heavy pressure for the darkest areas, such as at the base of the windshield and on the shadowed areas of the tires. Render the background with simple shapes to help direct focus to the car.

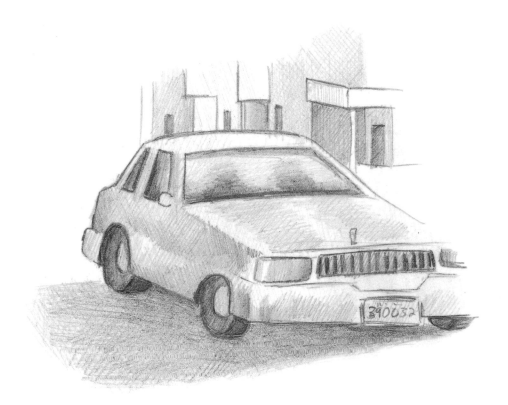

Old Tree

As you draw trees either from this book or outdoors, first work out the basic shapes with simple line drawings. For example, this tree is loosely sketched with straight lines for the trunk and branches and with curved lines for large groups of leaves.

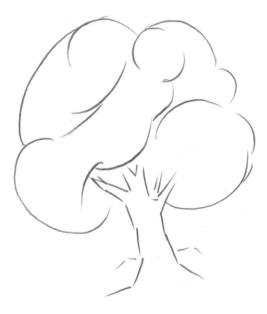

Step 1 Sketch the basic shapes using loose strokes and the tip of an HB pencil.

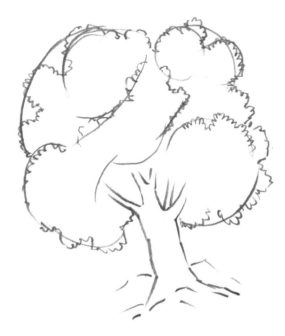

Step 2 Begin to refine the plumes of foliage with curly edges.

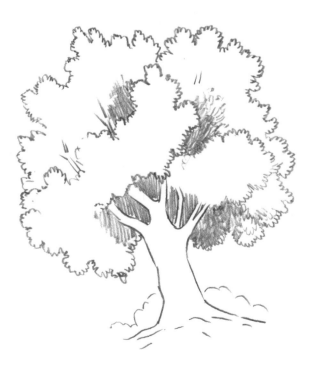

Step 3 Use a 2B pencil to shade the dark areas behind the branches, creating depth.

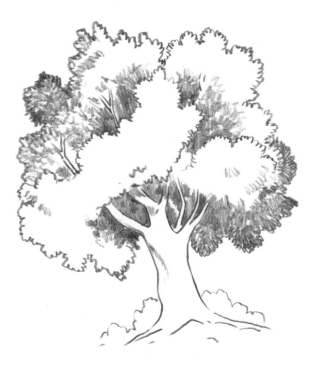

Step 4 Erase any lines you no longer need, and hatch in the areas of darkest shadow. Refine the trunk and background shapes.

Step 5 Now begin building the leaf texture over the plumes with small, curved lines and scribbles. Alternate between using the tip and side of the lead for variety. Finish suggesting leaves, allowing the tree's brightest highlights to remain free of graphite. Shade the background elements simply using hatched lines with the side of the lead.

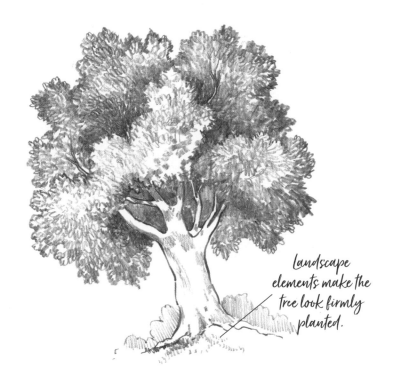

Landscape elements make the tree look firmly planted.

Mountains

Atmospheric perspective refers to the illusion of depth in a landscape. One way to suggest distance is to reduce detail in the farthest areas, reserving the most contrast and prominent linework for areas closer to the viewer.

Step 1 Block in the rocky mountain and foreground slopes with just a few sketch lines.

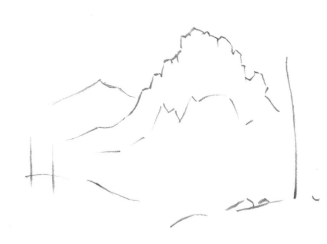

Step 2 Then suggest the distant mountain, adding another layer of distance, and indicate a few foreground trees.

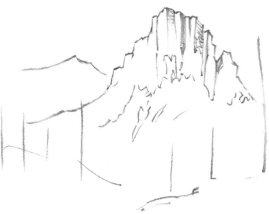

Step 3 Develop the edges of the craggy mountain, shading the planes in shadow and delineating the rocky areas.

Step 4 Continue hatching to shade areas facing away from the sun. For the foreground trees, use jagged squiggles and dark lines.

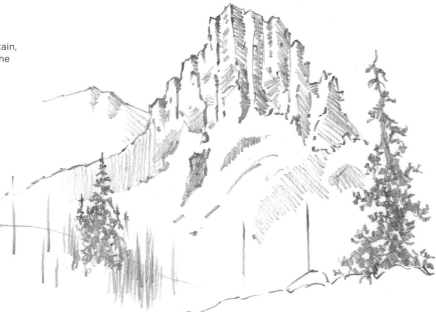

Step 5 Accent the forested area with more trees, using tapering, vertical strokes to fill in the gaps. Vary the light and dark values around the trees to make some appear farther away than others. Because the background mountains are in the distance, keep the shading less detailed.

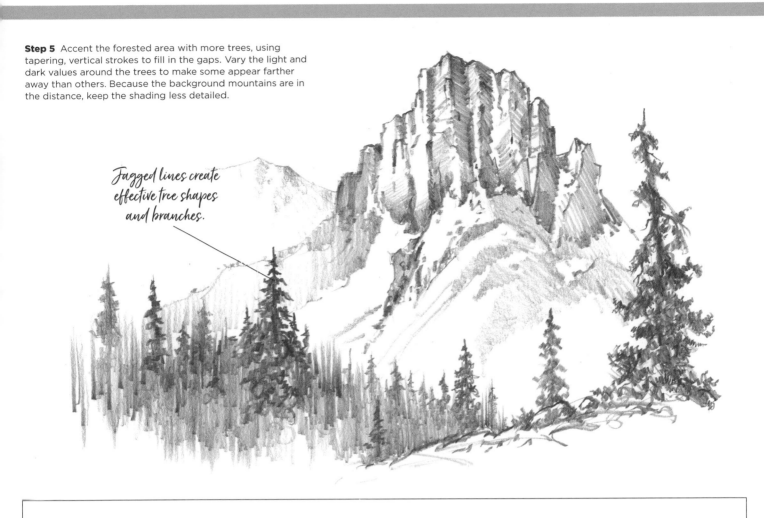

Jagged lines create effective tree shapes and branches.

Monument Valley

Emphasizing Size The great vertical stature of these incredible rocks produces a dramatic desert landscape. From this angle, it seems as though you are peering up at them; therefore, the rocks have an overpowering presence. Block in all the basic shapes before shading. Use a sharp 2B pencil to fill in the crevices and cracks. This drawing is unique because the shading in the foreground is darker than the shading in the background. This effect is caused by the position of the light source (the sun); it is to the left of the main rock formations, creating shadows on the right side of the rocks.

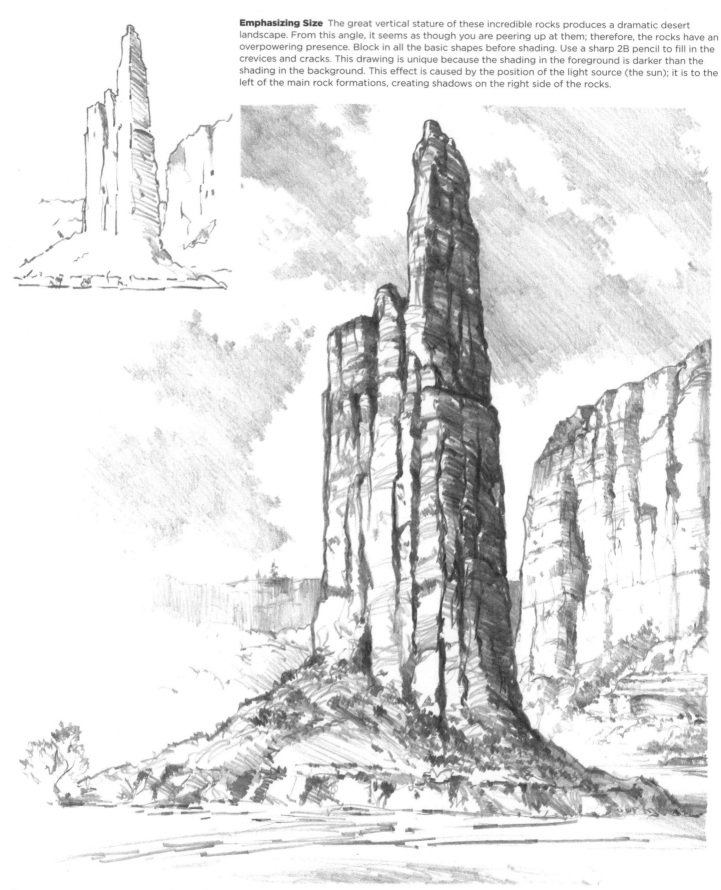

Deserts

Deserts make excellent landscape subjects; from brushy foliage and cactus skin to brightly lit sand and stone, these scenes are full of interesting textures, shapes, and shadows.

Step 1 Use an HB pencil to lay out the major elements and refine the shapes to create your desired composition.

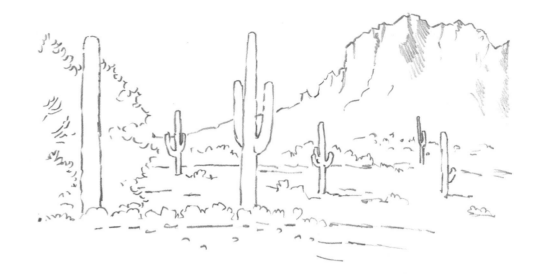

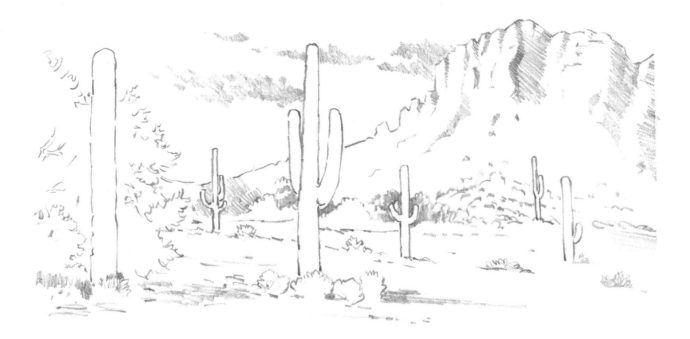

Step 2 Then add a few light shadows in the sky, over the rock formation, and within the brush. Keep the direction of light in mind as you shade.

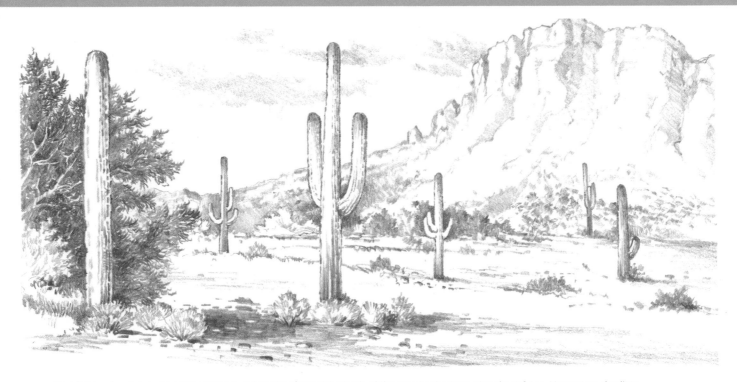

Step 3 Develop the darks of the foliage and stroke along the length of the cactus plants to give them form. Keep your shading minimal throughout to create the illusion of a sun-washed landscape.

Mill by the Stream

Notice that the drawing retains a sketchy, unfinished quality from start to finish, which gives it a fresh and spontaneous feel. As you progress in this project (and when working on your own pieces), try not to overwork your drawing.

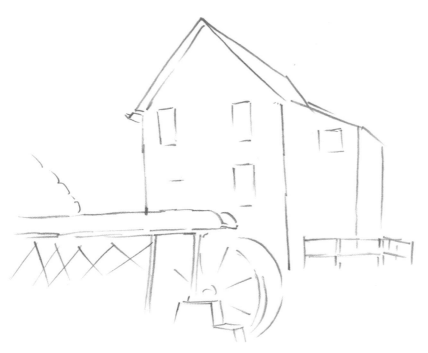

Step 1 Lightly sketch the major shapes with an HB pencil, using as few lines as possible. It's important to make sure your perspective is accurate before shading.

Step 2 Begin creating form by shading the background foliage with a 2B pencil. Apply strokes in various directions, studying closely where the shading values differ. Shade with long vertical strokes along the structure's wall, which will contrast the background. Begin shading and detailing the mill as well.

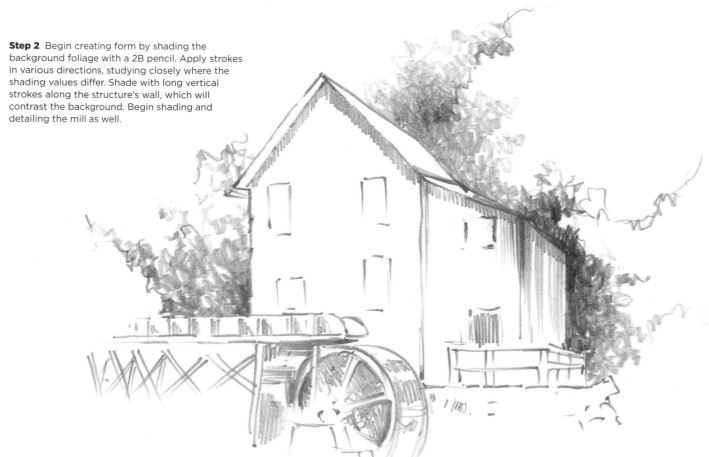

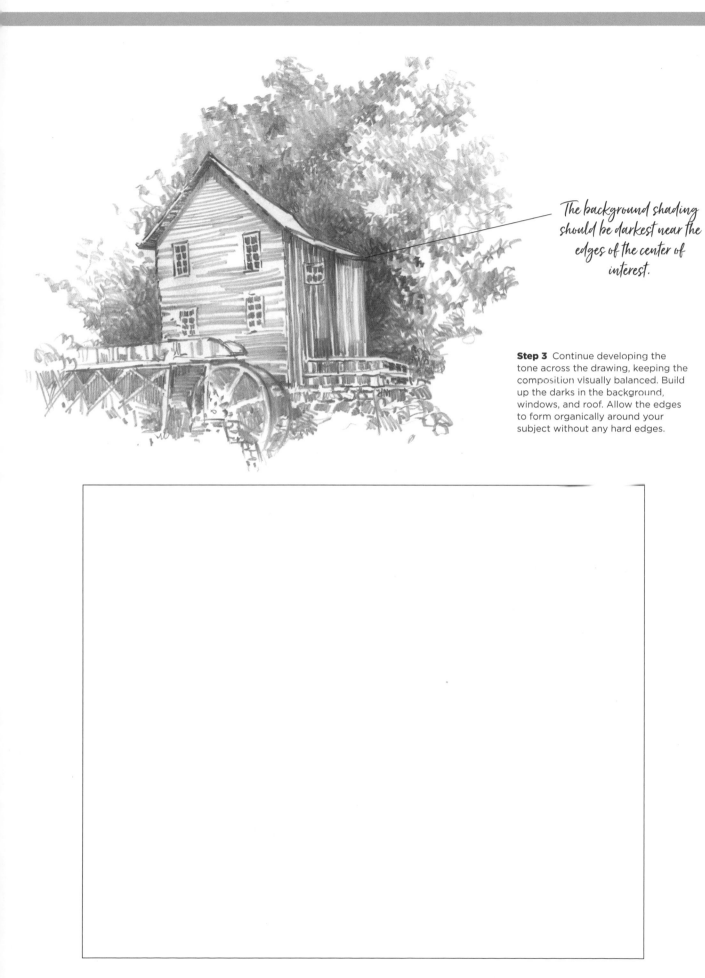

The background shading should be darkest near the edges of the center of interest.

Step 3 Continue developing the tone across the drawing, keeping the composition visually balanced. Build up the darks in the background, windows, and roof. Allow the edges to form organically around your subject without any hard edges.

Introducing Perspective

When drawing buildings and roads, remember that all parallel lines converge to points on the horizon (called "vanishing points"). Representing the angles of these lines accurately is important for achieving the illusion of three dimensions.

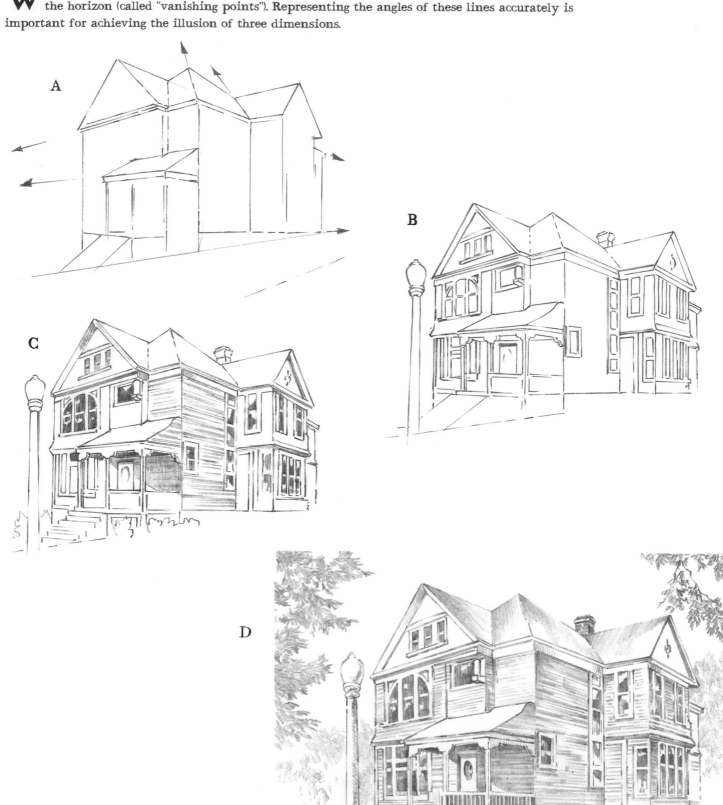

A

B

C

D

Capturing Vacation Scenes

Keep a camera close by when you travel; you may see an intriguing scene or subject without the time needed to sketch it. Photograph anything that catches your eye (asking permission when necessary), and experiment with composition and viewpoints. File them away for future drawing or painting references.

Step 1 For this sunset scene, lightly block in the outlines of all of the elements with the sharp point of the HB pencil. Notice that the horizon line is slightly below center.

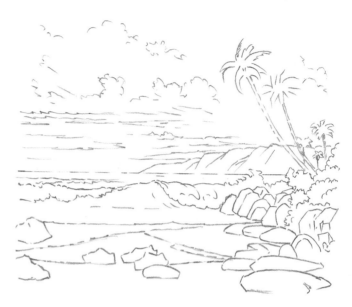

Step 2 As you develop the contours of each object, keep all guidelines light, especially in the sky. Just as you do with a still life, check that all elements are in correct proportion.

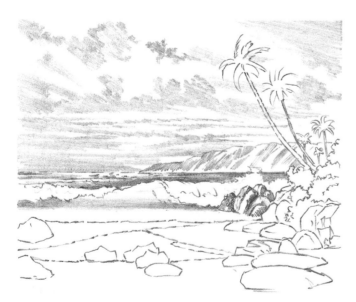

Step 3 Using the side of an HB pencil, build up the values and shapes of clouds in the sky, making most of your strokes follow the same angle. Then begin shading the water.

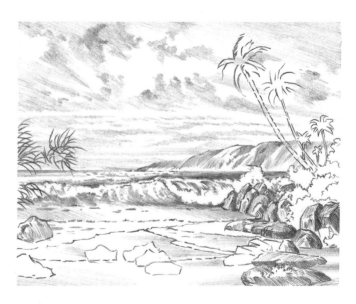

Step 4 Next continue adding details and developing depth with shading. Notice how the pencil strokes follow the surface of the water and the shapes of the rocks.

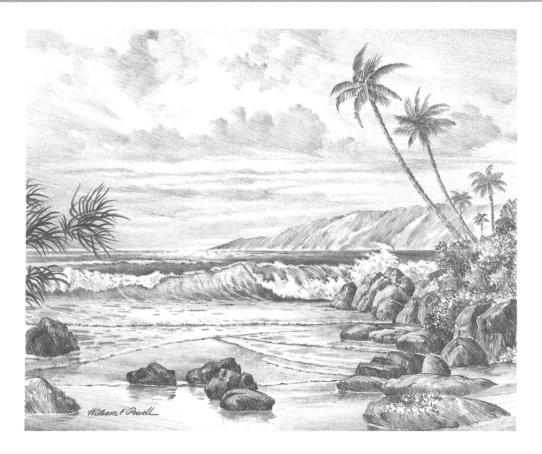

Step 5 Develop the shading values and textures using the point and sides of a 2B. Don't overwork the background; keep it light to suggest distance.

New York City

Understanding linear perspective is vital to any artist's repertoire—particularly when the subject matter involves streets and buildings. Applying the rules of perspective helps create the illusion of depth and distance in a drawing. Learning these rules is easier than one may think; for example, linear perspective simply dictates that all receding lines meet or vanish at one or more spots (called "vanishing points") on the horizon line (the imaginary line that represents the eye level or the actual horizon). Once you gain a basic understanding of perspective, you'll be able to re-create the sense of depth present in a street scene such as this busy avenue in New York City.

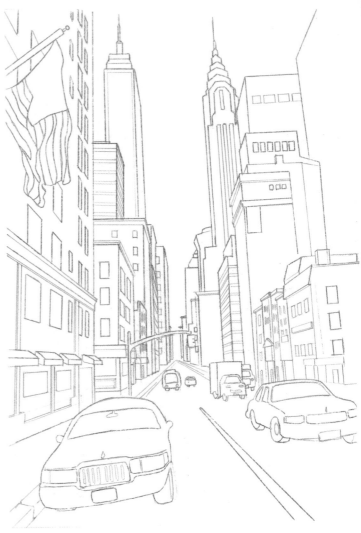

Step 1 Once you've placed the vanishing point (about one quarter of the way up the paper), sketch in the subject. Use a ruler to create the major outlines of the buildings, most of which appear like giant boxes. As you add the lines, make sure that the receding lines on the page converge at the vanishing point. Transfer the outlines of the foreground cars.

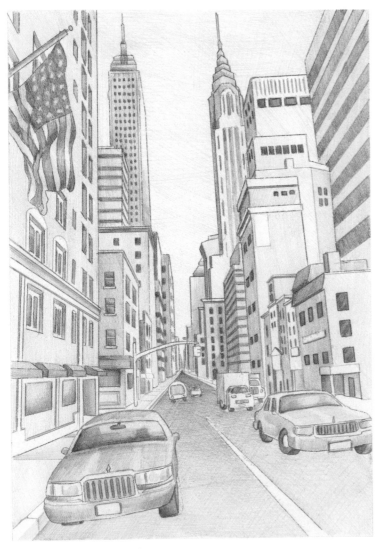

Step 2 After making sure that the basic outlines are accurate, continue using the ruler to add the windows, awnings, and ledges, ensuring that every parallel line along the street follows the rules of one-point perspective. To simplify busy city scenes a bit, avoid adding every line from your reference, placing only those that define important shapes.

Animals
Basic Shapes

Below are several animal drawings that are made up of simplified shapes. As you can see, cylinders, circles, and ovals form the basic structure of each drawing. When you take your sketchbook out into the field and begin to draw, start with these simple shapes and lines. Work quickly and freely, and keep the drawing simple. Don't be worried if the animal is moving; just start another drawing on the same or next page. An animal usually will pace and return to its previous position so you can continue where the first or second drawing left off. Fill your page with several different views and angles of the moving animal. Don't fuss over small details; try to capture the overall form and feeling of the animal. Your aim is to take a quick "snapshot" in pencil.

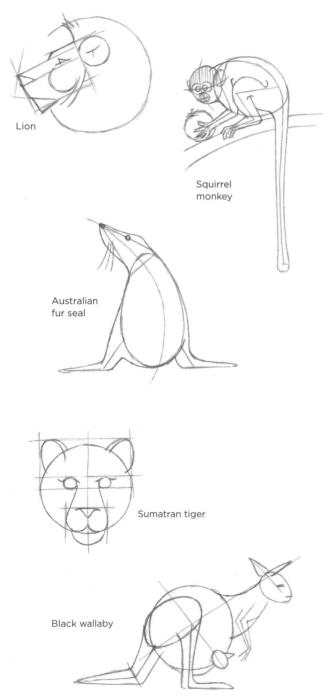

Lion

Squirrel monkey

Australian fur seal

Sumatran tiger

Black wallaby

Drawing Accurately

Accuracy is essential to drawing lifelike animals. If you are drawing in a more impressionistic manner, clinical accuracy is not as important—but your drawing must still retain a degree of reality to convince the viewer that your drawing is believable. Follow the three steps below to render the profile of a lioness with believable accuracy.

Starting Simply This profile can be seen as a combination of triangles, wedges, circles, and lines. Start by drawing two plumb lines (vertical lines), crossing these with two horizontal lines. Within the square formed where the lines intersect, draw a triangle to represent the eye. Then use a series of straight lines to mark the angles and positions of the head and features. Now you have a basic structure drawing.

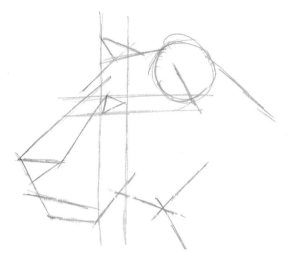

Drawing Freehand

Freehand drawing is a skill that every artist needs to develop and practice, as it helps you observe and understand the form and structure of your subject. The more you practice, the better you will become. Start your freehand work by observing and then breaking down the subject into simple shapes and measurement guidelines.

Developing the Drawing Continue drawing with confident strokes, building up the shape as you develop the drawing. Don't erase all your structure lines; build on them using a series of "searching" lines to establish shape, darkening the lines you think are most correct. It doesn't matter if the drawing gets a bit messy with all your searching lines, as the viewer's eye will be attracted to the darker, corrected line.

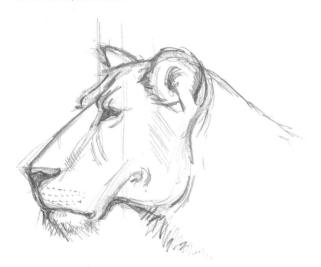

Creating Animal Textures

Smooth Scales To depict smooth scales, draw ovals of various sizes; then shade between them. Because scales overlap, partially cover each scale with the next layer.

Rough Scales For rough scales, create irregular shapes that follow a curved alignment. Shade darkly between shapes; then shade them with light, parallel strokes.

Fine Feathers For light, downy feathers, apply thin, parallel lines along the feather stems, forming a series of V shapes. Avoid crisp outlines to maintain softness.

Heavy Feathers For thick, more defined feathers, use heavier parallel strokes and blend with a tortillon. Apply the most graphite to the shadows between the feathers.

Hide To create a shiny, short-haired hide, apply short, straight strokes with the broad side of the pencil. For subtle wrinkles, add a few horizontal stripes that are lighter in value.

Wavy Hair For layers of soft curls, stroke S-shaped lines that end in tighter curves. Leave the highlights white and stroke with more pressure toward the shadows.

Rough Coat For stripes, apply short strokes in the direction of fur growth. Then apply darker strokes in irregular horizontal bands. Pull out highlights with an eraser.

Smooth Coat For a smooth coat, use sweeping parallel pencil strokes, leaving the highlighted areas white. Use both the pencil tip and the broad side for variation.

Curly Hair Draw curly, wooly coats with overlapping circular strokes of varying values. For realism, vary the curl shapes and sizes. Blend for softness.

Long Hair To render long hair—whether it's the whole coat or just a mane or tail—use longer, sweeping strokes that curve slightly, and taper the hairs to a point at the ends.

Whiskers For whiskers, first apply rows of dots on the animal's cheek. Fill in the fur as you have elsewhere; then, with the tip of a kneaded eraser, lift out thin, curving lines.

Nose Most animal noses have a bumpy texture that resembles a very light scale pattern. Add a shadow beneath the nose; then pull out highlights with an eraser.

Rabbits

Drawing rabbits requires you to observe them carefully. For example, ear length varies with different breeds. The ears on this guy may be a bit smaller than your subject.

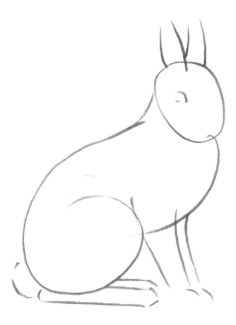

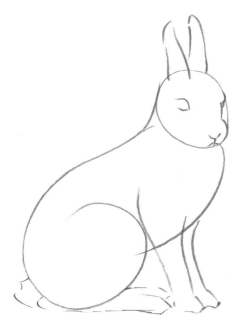

Step 1 Use ovals, circles, and loose strokes to block in the rabbit's general shape. At this stage, focus on trying to catch the mood of the pose as much as the shapes.

Step 2 Refine the shapes of the ears and the face, placing the eyes, nose, and mouth.

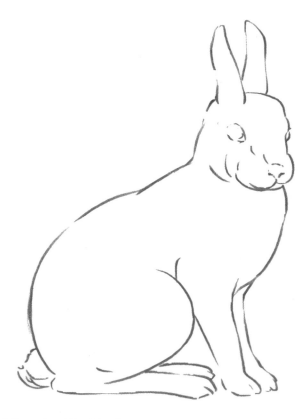

Step 3 Once the pose is set, refine the outlines and erase any original sketch lines you no longer need.

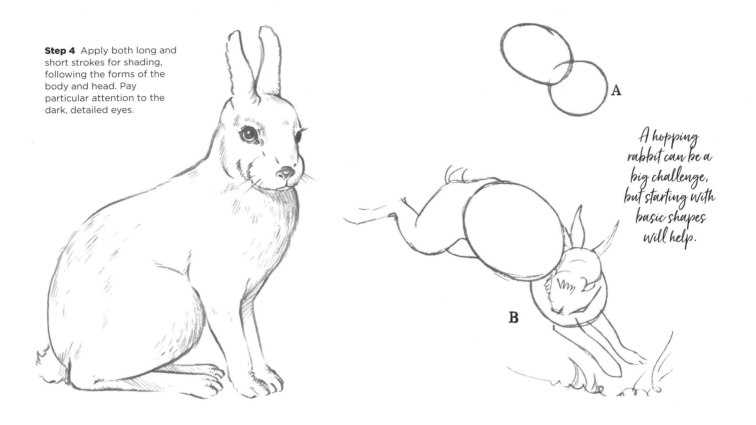

Step 4 Apply both long and short strokes for shading, following the forms of the body and head. Pay particular attention to the dark, detailed eyes.

A

A hopping rabbit can be a big challenge, but starting with basic shapes will help.

B

Cats

It sometimes can be difficult to capture a cat's shape when it sits or sleeps. It may stand up and wander away right in the middle of your drawing! Don't worry about always completely finishing your renderings; instead, do quick, spontaneous sketches of the cat's different movements and poses. These quick studies are good practice.

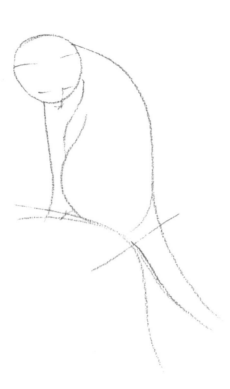

Step 2 Shade the fur with broad strokes using the side of your pencil or washes of ink, and then apply darker, wavy lines to bring out the cat's striped coat. The eyes are merely slits because the cat is looking down.

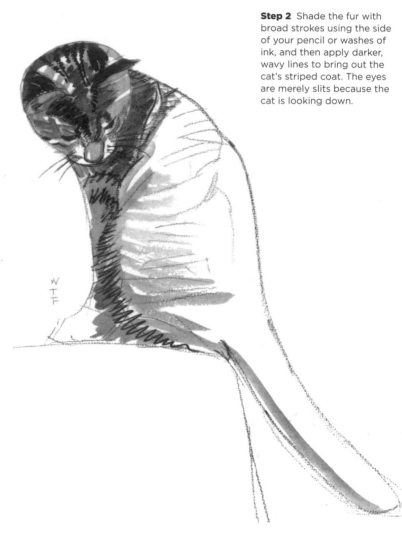

Step 1 The body position and simplicity of this cat give it a beautifully fluid look. Begin by drawing a circle for the head with an HB pencil. Next draw lines to indicate the placement of the features and the curves of the back, tail, and haunches. Try to capture the gesture, or pose, with just a few loose strokes.

A

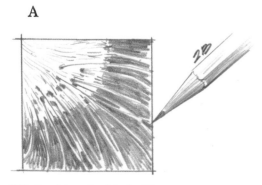

With the side and point of a 2B pencil, indicate the fur and whiskers.

B

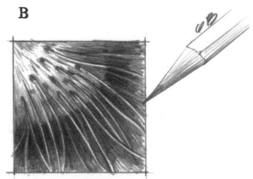

Use a 6B pencil to refine the whiskers and shade the darkest areas.

Sparrow

This delicate sparrow on a pussy willow branch is finished in detail but begins with the same simple shapes. Notice that the block-in lines are loose and only lightly structured. This will keep your drawing from looking stiff and artificial.

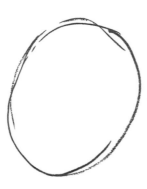

Step 1 Start with a simple egg shape for the bird's body. Notice that the oval is slightly broader at the top.

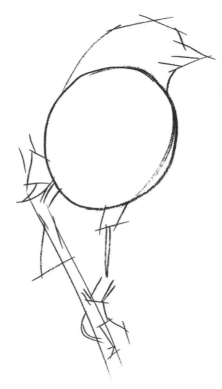

Step 2 Working around the oval, block in the head, beak, branch, and feet. This is the time to make sure the proportions are accurate.

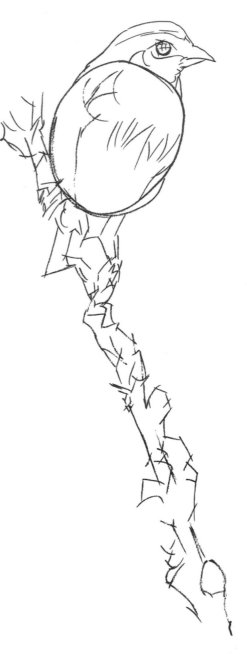

Step 3 Further develop the branch and head. Suggest feathers on the breast, stroking in the direction in which the feathers lay over the forms.

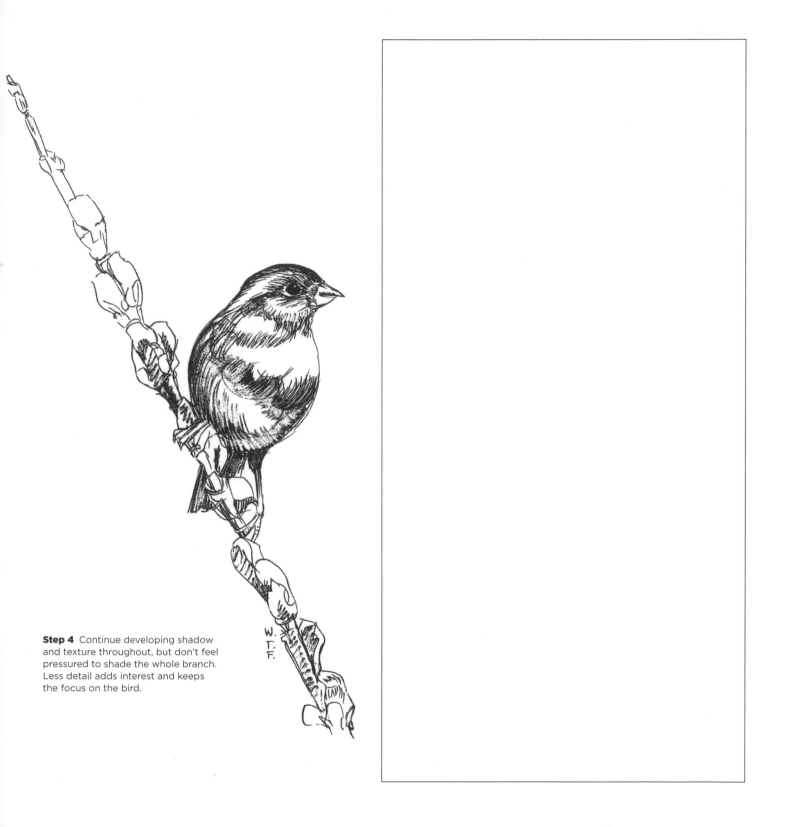

Step 4 Continue developing shadow and texture throughout, but don't feel pressured to shade the whole branch. Less detail adds interest and keeps the focus on the bird.

Kangaroo

With the kangaroo, it's especially important to draw what you see, not what you expect to see. Study the features of the animal before beginning. For example, notice that the kangaroo's ears, tail, and feet are disproportionately large in comparison to its other features. Attention to detail will produce a more accurate final drawing.

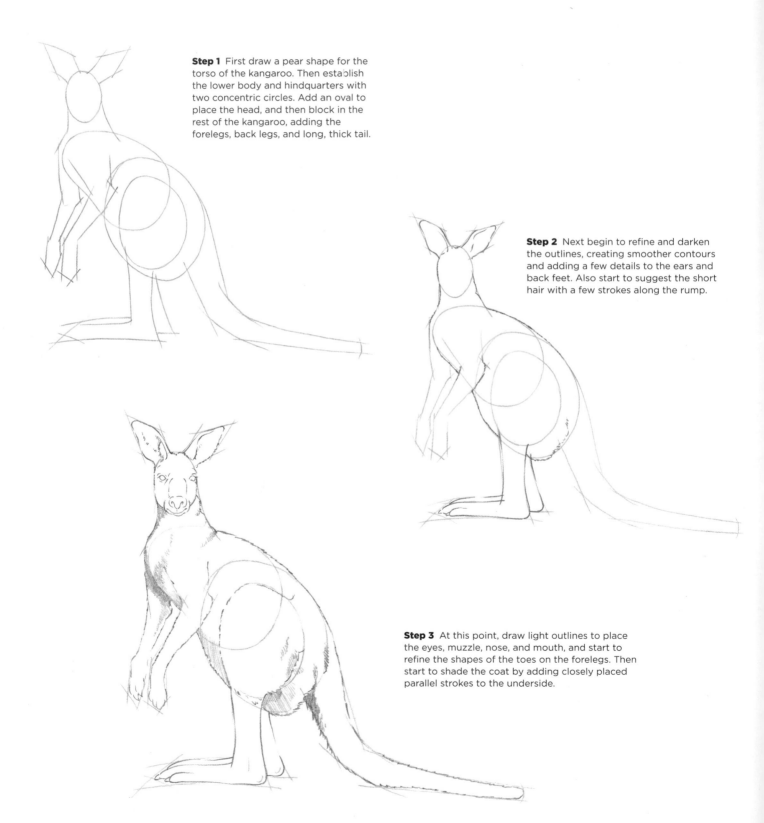

Step 1 First draw a pear shape for the torso of the kangaroo. Then establish the lower body and hindquarters with two concentric circles. Add an oval to place the head, and then block in the rest of the kangaroo, adding the forelegs, back legs, and long, thick tail.

Step 2 Next begin to refine and darken the outlines, creating smoother contours and adding a few details to the ears and back feet. Also start to suggest the short hair with a few strokes along the rump.

Step 3 At this point, draw light outlines to place the eyes, muzzle, nose, and mouth, and start to refine the shapes of the toes on the forelegs. Then start to shade the coat by adding closely placed parallel strokes to the underside.

Step 4 Now erase any remaining guidelines that still show from the initial sketch and continue to develop the coat texture. Add the suggestion of the muscles under the kangaroo's coat with short, curved strokes. Then complete the details on the claws and face, filling in the eyes and nose. Finally, add a cast shadow, stroking diagonally with the side of an HB pencil.

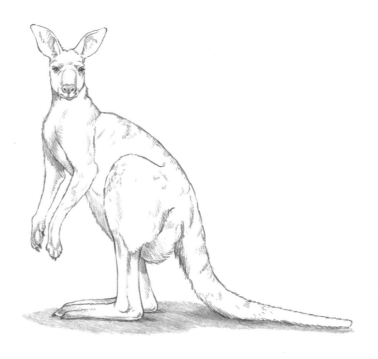

Giraffe

Accurate proportions are important for drawing a giraffe; when blocking in your drawing, consider how making the legs too short or the neck too thick would alter the animal's appearance. Use the head as a unit of measurement to draw the rest of the body in correct proportion—for example, pay attention to how many heads long the legs and neck are.

Step 1 To begin, block in the basic shape of the giraffe, adjusting the lines until you are satisfied with the proportions. Notice that the giraffe's neck is as long as its legs, and its hindquarters slope down sharply.

Step 2 Now begin to refine the shapes of the legs and rump, smoothing the outline. Then begin placing the features and blocking in the pattern of the coat. For this species of giraffe, the spots all have slightly different irregular shapes, with small gaps between them.

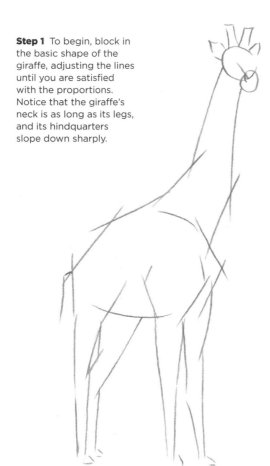

Drawing the Head

Start with a circle for the head and two smaller circles for the muzzle; then add the horns and ears. Draw a curved jaw line, and sketch in the eyes—and eyelashes—and inner ear details. Then refine all the outlines and shade the face, using a soft pencil for the dark areas and changing the direction of the strokes to follow the forms.

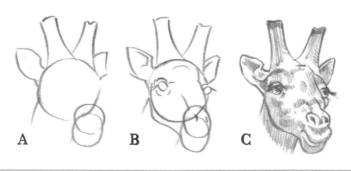

A B C

Step 3 Now erase any stray sketch marks and focus your attention on rendering the giraffe's face. (See the details in the box on page 66.) Then fill in all the dark patches of the coat, adding the mane with a 2B pencil and short, dense diagonal strokes.

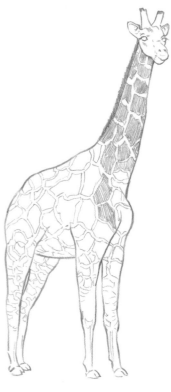

Step 4 In this final step, after shading the face, add the shading beneath the giraffe's body and head. To keep the giraffe from appearing to float on the page, draw the ground with tightly spaced diagonal strokes.

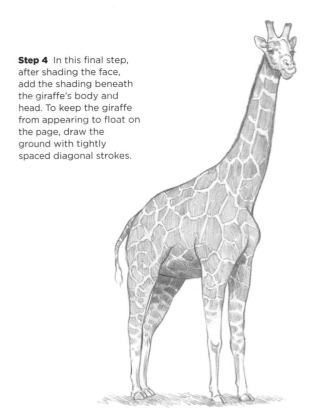

Baby Monkey

Baby animals are popular subjects to draw, and this little fellow is especially charming. The body is egg-shaped, and the head evolves from a simple circle. As in the previous drawings, most subjects can be reduced to basic elements such as ovals, circles, or straight lines. Learn to recognize these shapes within your drawing subjects, and your skills will improve immensely.

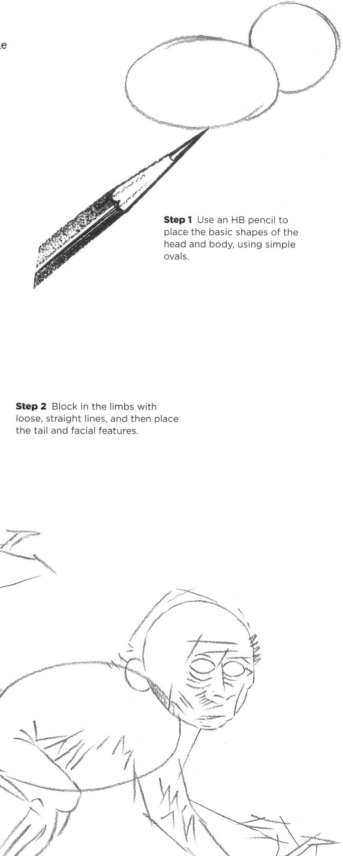

Step 1 Use an HB pencil to place the basic shapes of the head and body, using simple ovals.

Step 2 Block in the limbs with loose, straight lines, and then place the tail and facial features.

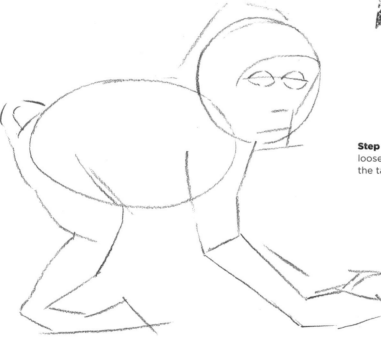

Step 3 Sketch in some lines that describe the form.

Step 4 Using your pencil lines as guides, shade the monkey using both pencil and ink or watercolor. Apply your washes with a small round brush. Create the illusion of fur with short slash marks that follow the curves of the body's form. Mold a kneaded eraser into a point to pull out highlights within the fur, lifting at the end of each stroke.

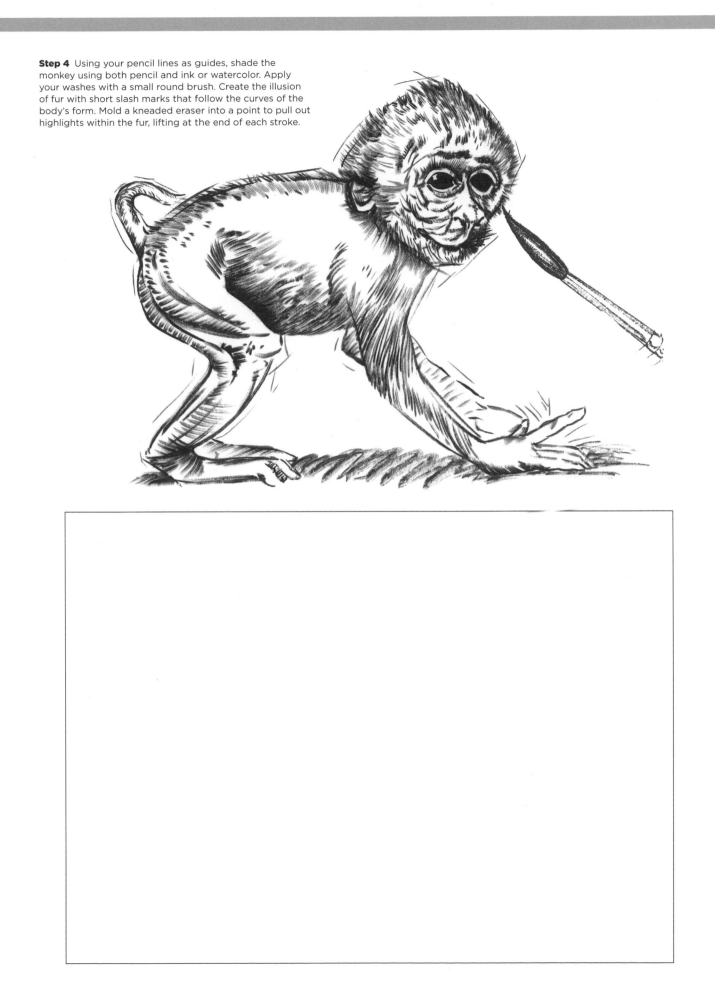

Golden Retriever

The Golden Retriever is one of the most beloved dog breeds in the world; these family-friendly dogs are both energetic and easygoing, as captured in this drawing. When you draw an animal, try to incorporate some of its personality in the pose and expression.

Step 1 First establish the gesture line of the sitting dog with a curve that spans from the top of the head to the ground. Then cross it with a curved horizontal line to mark the center of the chest. Along the vertical line, add ovals and a circle for the head, muzzle, chest, and body; also place an oval for the left hind leg.

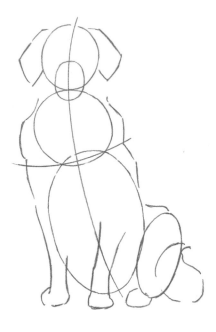

Step 2 Next add the basic shapes of the folded ears, and roughly outline the body around the ovals, adding the front legs, paws, and tail.

Step 3 Now erase the initial guidelines for the body. Then add sweeping, curved lines along the chest and body to suggest roundness. Add guidelines for the facial features, placing a line for the eyes about one-third of the way down the face and lines for the nose about one-half of the way down. Then use straight strokes to mark the individual toes.

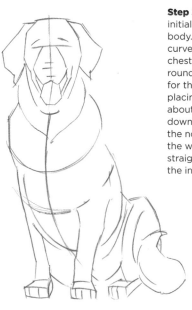

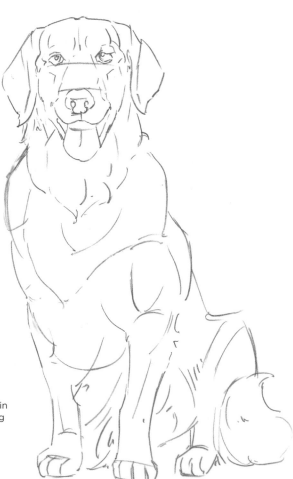

Step 4 At this point, place the facial features according to the guidelines. Then, following the curved guidelines created in step 3, add V-shaped marks over the chest to indicate the ruff, and sketch in the first waves of the coat. Then erase the initial gesture mark, along with any additional remaining guidelines.

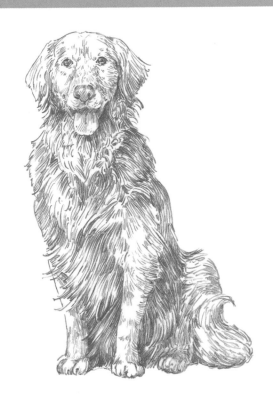

Step 5 Now develop the texture of the coat, stroking in the direction of the fur growth. Notice that the hair on the face is short, growing outward and down from the nose and eyes. The lower front legs and paws also have short hair, which you can suggest with quick hatch marks. The rest of the body has longer hair, so use flowing, wavy strokes of varying thicknesses. Finally, lightly blend the strokes by dragging a wedge-shaped kneaded eraser over them, following the curve and direction of the strokes as you drag.

Horse Portrait

Horses are fantastic drawing subjects, as their inherent beauty and grace can be quite captivating. Pay careful attention to the detail of the eye to express this gentle creature's warmth and intelligence.

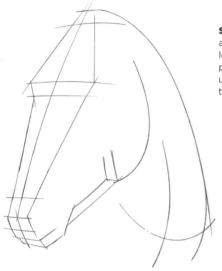

Step 1 First establish the structure and angle of the head and neck with long strokes. Then mark several planes with horizontal strokes, setting up guidelines for the placement of the eyes, nose, and mouth.

Step 2 Now use the initial guidelines to place the ears, eyes, nostrils, and mouth. (The eyes are about one-third of the way down the horse's head.) Also refine the outline of the neck and jaw line.

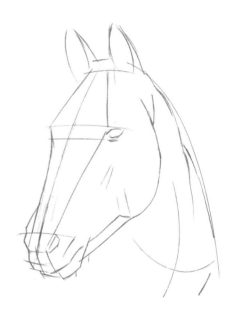

Horse Details

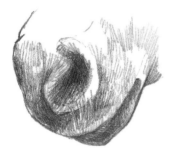

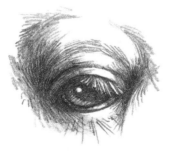

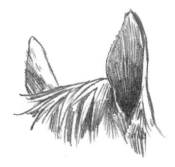

Muzzle The muzzle has subtle, curved forms, which are defined with careful shading. The area around the nostril is raised, as is the area just above the mouth; indicate this shape by pulling out highlights with a kneaded eraser.

Eye Horses' eyes have a lot of detail, from the creases around the eyes to the straight, thick eyelashes that protect them. To create a sense of life in the eye, leave a light crescent-shaped area to show reflected light, and leave a stark white highlight above it.

Ears Render the horse's forelock hair with long, slightly curving strokes. Then shade the interior of the ear with upward parallel strokes, making them darkest at the bottom and gradually lighter as you move up the ear.

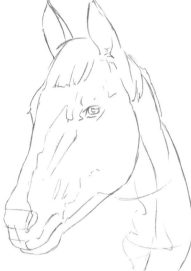

Step 3 Next erase any guidelines that you no longer need and add the forelock between the ears. Use thin, irregular lines to indicate the value changes on the horse's face. Then add a little more detail to the horse's eye.

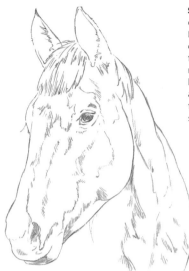

Step 4 At this point, begin to develop the texture of the coat. Now replace the solid lines that divide the values of the horse's face with a series of short hatch marks that follow the direction of hair growth. Fill in the eye, and add long strokes to the mane and forelock to contrast with the short hairs of the coat.

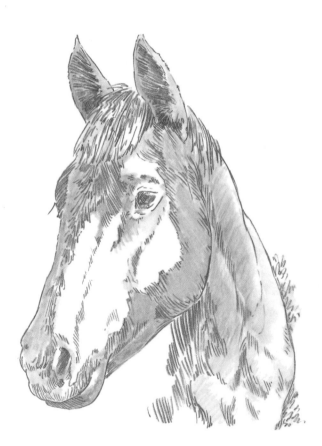

Step 5 Now create the dark areas of the coat using a large blending stump dipped in graphite dust. Apply broad strokes, fading them out as you work down the neck. With a smaller stump, add more detail and shading around the eye and ears. Finally, enhance the sense of depth by adding darker graphite strokes in the shadows of the ears and under the head.

Iguana

Complementing a pencil drawing with ink washes adds contrast and drama to your work. In this project, applying varying values of ink is a quick way to lay in shadows and build up the iguana's scaly skin.

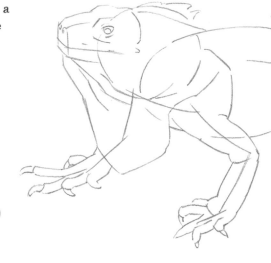

Step 1 Begin with a few pencil gesture lines, one for each visible leg and one curving from the top of the head down to the tip of the tail. Then block in the head and body, and create the boxy shape of the lizard's mouth and nose.

Step 2 Now begin to outline the iguana, adding the droop of skin beneath the round chin and defining each toe and claw. Adjust the lines as you draw, knowing that you will eventually erase all the pencil marks as you transform your drawing with pen and ink.

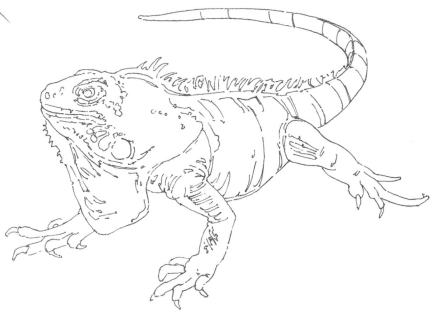

Step 3 At this point, I finish the outline with a waterproof ink pen. Add the striped pattern to the tail and the spikes along the iguana's back. Use a few strokes to show the iguana's rough skin, as well as curving lines that suggest the sag under the skin. After the ink dries, erase your initial pencil marks.

Varying Values with Ink Washes

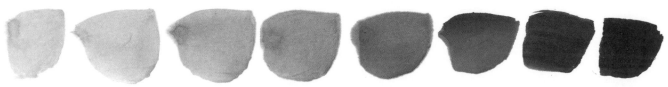

Adjusting the amount of water you use in your ink washes can provide a variety of different values. It is best to start with the lightest value and build up to a darker wash, rather than adding water to a dark wash.

Create a value chart like the one above. Start with a very diluted wash at the left, and gradually add more pigment for successively darker values.

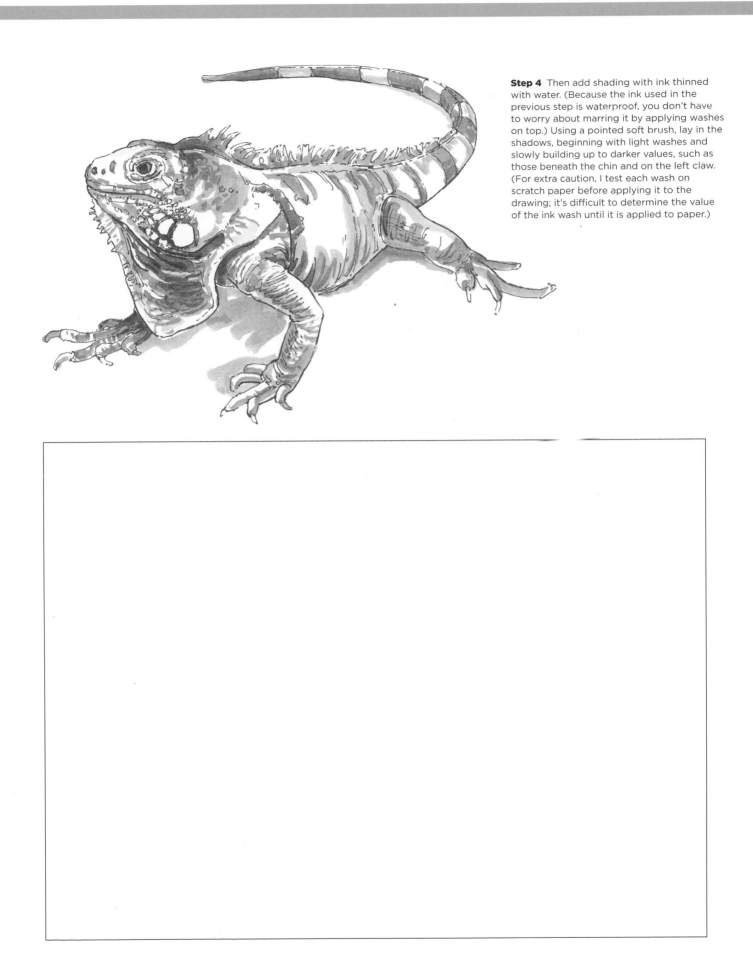

Step 4 Then add shading with ink thinned with water. (Because the ink used in the previous step is waterproof, you don't have to worry about marring it by applying washes on top.) Using a pointed soft brush, lay in the shadows, beginning with light washes and slowly building up to darker values, such as those beneath the chin and on the left claw. (For extra caution, I test each wash on scratch paper before applying it to the drawing; it's difficult to determine the value of the ink wash until it is applied to paper.)

Gorilla

Gorillas may be covered in long hair, but they have humanlike features that require attention to detail. In fact, drawing a gorilla is a great case study in capturing an expression and a likeness. Watch the furrow of the brows and how the eyes move as it interacts with its environment, and examine how the line of the mouth changes.

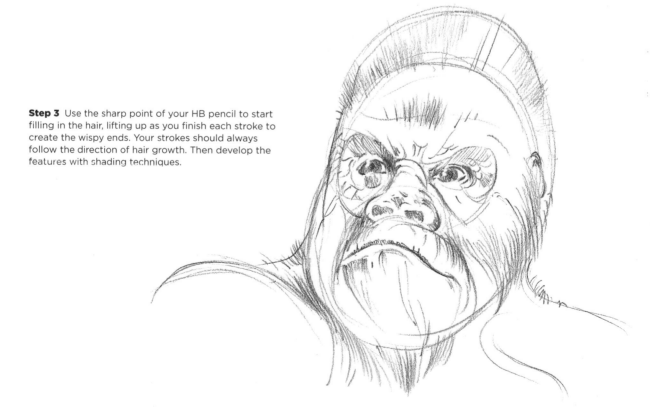

Step 2 In this step, start adding details to the eyes, nose, and mouth. Place the ear, aligning it with the brow. Then begin suggesting the basic hair patterns, following the curves of the face and shoulders.

Step 1 Adult gorillas often sit and observe their onlookers, giving you enough time to make fairly detailed drawings. Begin by lightly sketching some loose ovals to work out the shapes of the head and shoulders. Then draw shapes to suggest the features and a line to indicate the brow.

Step 3 Use the sharp point of your HB pencil to start filling in the hair, lifting up as you finish each stroke to create the wispy ends. Your strokes should always follow the direction of hair growth. Then develop the features with shading techniques.

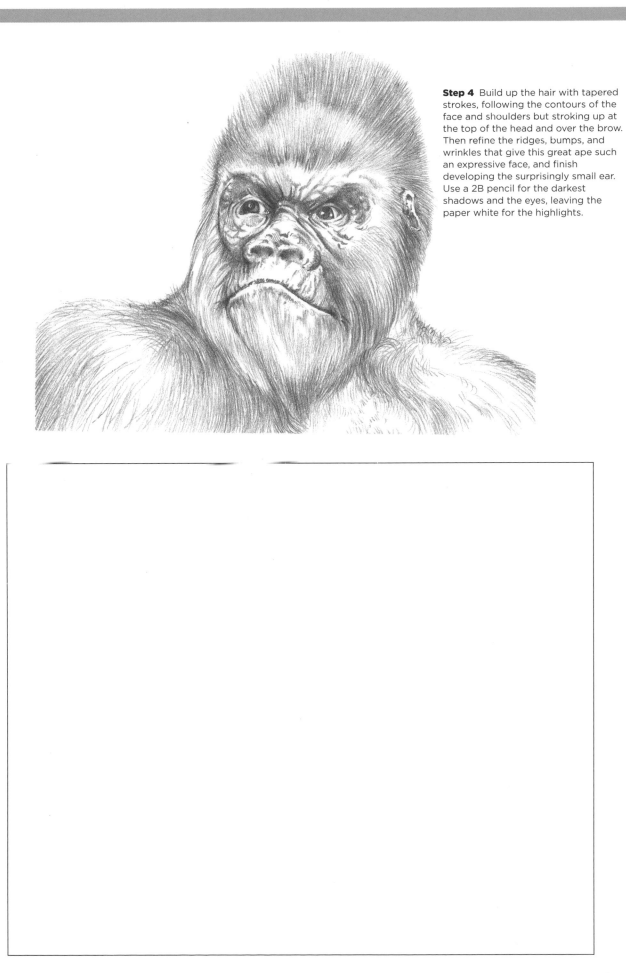

Step 4 Build up the hair with tapered strokes, following the contours of the face and shoulders but stroking up at the top of the head and over the brow. Then refine the ridges, bumps, and wrinkles that give this great ape such an expressive face, and finish developing the surprisingly small ear. Use a 2B pencil for the darkest shadows and the eyes, leaving the paper white for the highlights.

People
Eyes

If you're a beginner, it's a good idea to practice drawing all the facial features separately, working out any problems before attempting a complete portrait. Facial features work together to convey everything from mood and emotion to age. Pay attention to the areas around the features, as well; wrinkles, moles, and other similar characteristics help make your subject distinct.

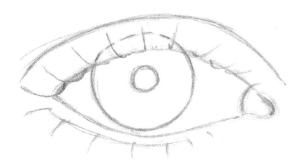

Step 1 Make a circle for the iris first; then draw the eyelid over it. (Drawing an entire object before adding any overlapping elements is called "drawing through.") Note that part of the iris is always covered by the eyelid.

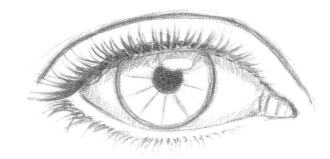

Step 2 Start shading the iris, drawing lines that radiate out from the pupil. Then add the eyelashes and the shadow being cast on the eyeball from the upper lid and eyelashes, working around the highlight on the iris.

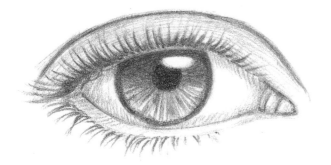

Step 3 Continue shading the iris, stroking outward from the pupil. Then shade the eyelid and the white of the eye to add three-dimensional form.

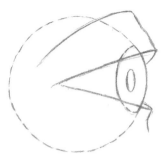

Step 1 Draw through a circle for the eye first; then draw the eyelid around it, as shown. In a profile view, the iris and pupil are ellipses; the top and bottom of the iris are covered by the upper and lower eyelids.

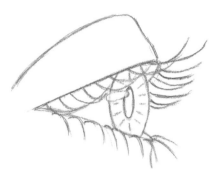

Step 2 To draw eyelashes in profile, start at the outside corner of the eye and make quick, curved lines, always stroking in the direction of growth. The longest lashes are at the center of the eye.

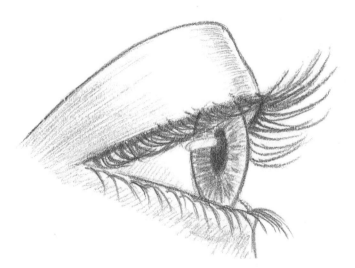

Step 3 When shading the eyelid, make light lines that follow the curve of the eyelid. As with the frontal view, the shading in the iris radiates out from the pupil.

Nose & Ears

Rendering Noses

To draw a nose, first block in the four planes—two for the bridge and two for the sides. Then study the way each plane is lit before adding the dark and light values. The nostrils should be shaded lightly; if they're too dark, they'll draw attention away from the rest of the face.

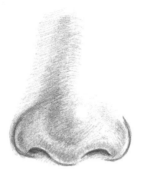

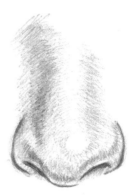

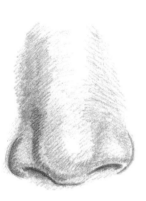

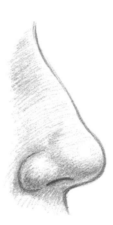

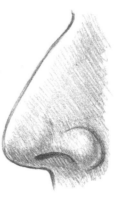

Ear Details

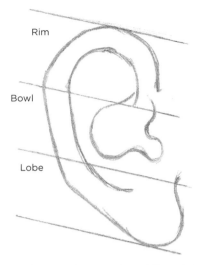

Rim

Bowl

Lobe

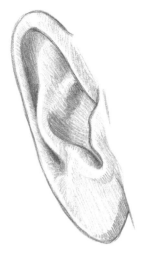

Dividing the Ear The ear is shaped like a disk that is divided into three parts: the rim, the bowl, and the lobe.

Sizing the Ear The ear usually connects to the head at a slight angle; the width is generally about one-half of the length.

Ear in Profile

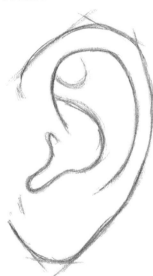

Step 1 First block in the general shape, visually dividing it into its three main parts.

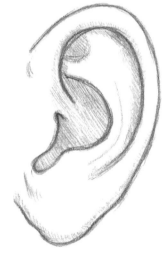

Step 2 Next start shading the darkest areas, defining the ridges and folds.

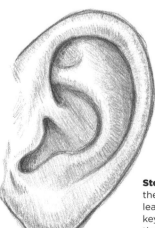

Step 3 Then shade the entire ear, leaving highlights in key areas to create the illusion of form.

Lips

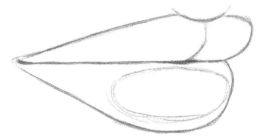

Step 1 When drawing lips, first sketch the basic outline. The top lip slightly protrudes over the bottom lip; the bottom lip is also usually fuller than the top lip.

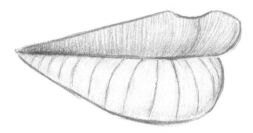

Step 2 Next begin shading in the direction of the planes of the lips. The shading on the top lip curves upward, and the shading on the bottom lip curves downward.

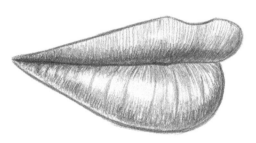

Step 3 Use hatch marks to build up tone along the shadowed edges. Leave the strongest highlights on the bottom lip free of graphite.

Combining Features

Step 1 First simplify the nose by dividing it into four planes—plus a circle on the tip to indicate its roundness. Then draw the outline of the lips. Add a small circle to connect the base of the nose with the top of the lip. The arrows on the lips indicate the direction of shading.

Step 2 Now lightly shade the sides of the nose, as well as the nostrils and the area between the nose and lips. Begin shading the lips in the direction indicated by the arrows in step 1. Then shade the dark area between the top and bottom lips. This helps separate the lips and gives them form.

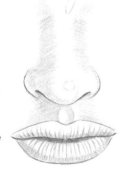

Step 3 Continue shading to create the forms of the nose and mouth. Where appropriate, retain lighter areas for highlights and to show reflected light. Use a kneaded eraser to pull out highlights on the top lip, on the tip of the nose, and on the bridge of the nose.

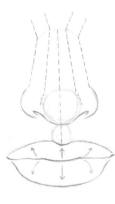

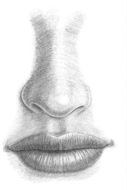

Detailing the Lips

Determine how much detail you'd like to add to your renderings of lips. You can add smile lines and dimples (A, B, and D), you can draw clearly defined teeth (A) or parts of the teeth (E and F), or you can draw closed lips (B, C, and D).

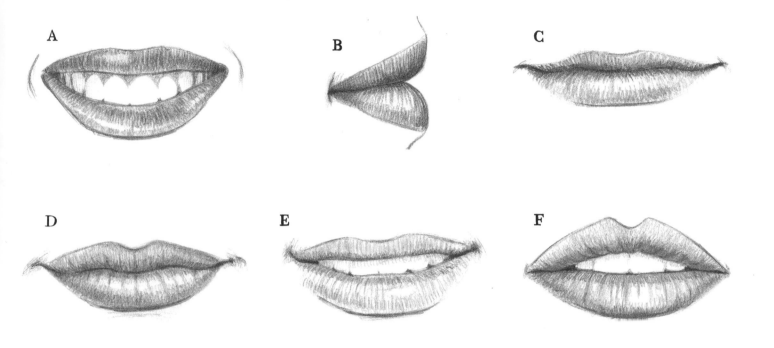

Studying Adult Proportions

Understanding the basic rules of human proportions (meaning the comparative sizes and placement of parts to one another) is imperative for accurately drawing the human face. Understanding proper proportions will help you determine the correct size and placement of each facial feature, as well as how to modify them to fit the unique, individual characteristics of your subject.

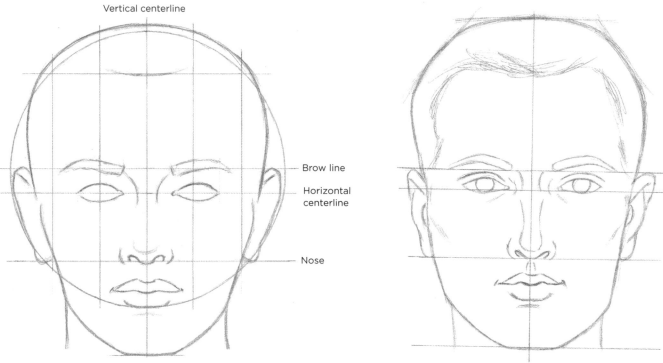

Vertical centerline

Brow line

Horizontal centerline

Nose

Establishing Guidelines Visualize the head as a ball that has been flattened on the sides. The ball is divided in half horizontally and vertically, and the face is divided horizontally into three equal parts: the hairline, the brow line, and the line for the nose. Use these guidelines to place the features.

Placing the Features The eyes lie between the horizontal centerline and the brow line. The bottom of the nose is halfway between the brow line and the bottom of the chin. The bottom lip is halfway between the bottom of the nose and the chin, and the ears extend from the brow line to the bottom of the nose.

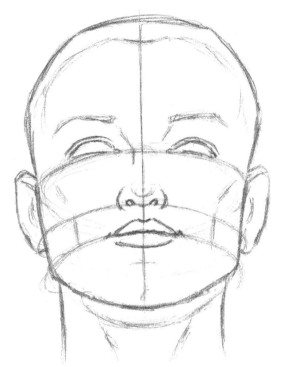

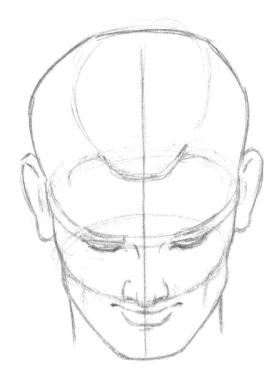

Looking Up When the head is tilted back, the horizontal guidelines curve with the shape of the face. Note the way the features change when the head tilts back: The ears appear a little lower on the head, and more of the whites of the eyes are visible.

Looking Down When the head is tilted forward, the eyes appear closed and much more of the top of the head is visible. The ears appear higher, almost lining up with the hairline and following the curve of the horizontal guideline.

Approaching a Profile View

A profile view can be very dramatic. Seeing only one side of the face can bring out a subject's distinctive features, such as a protruding brow, an upturned nose, or a strong chin. Because parts of the face appear more prominent in profile, be careful not to allow any one feature to dominate the entire drawing. Take your time working out the proportions before drawing the complete portrait.

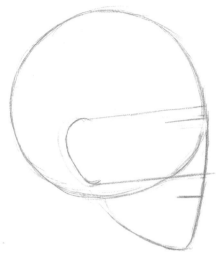

Step 1 After lightly drawing a circle for the cranial mass, use an HB pencil to block in the general shapes of the face, chin, and jaw line. Then add guidelines for the eyes, nose, mouth, and ear. Remember to closely observe your subject to see how the positions and angles of the features differ from the "average."

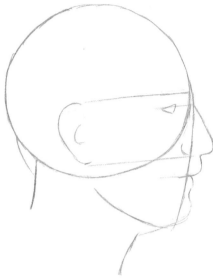

Step 2 Following the guidelines, rough in the shapes of the features, including the slightly protruding upper lip. Then sketch the eye, noting how little of it you actually see in a profile view.

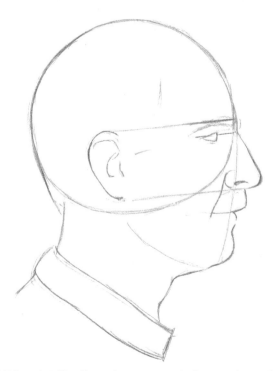

Step 3 When sketching the eyebrow, pay particular attention to the space between the eye and the eyebrow; in this case, the subject's eyebrow is fairly close to his eye. It also grows past the inside corner of his eye, very close to his nose, and tapers toward the outside corner of the eye. Continue refining the profile, carefully defining the shapes of the chin and the neck.

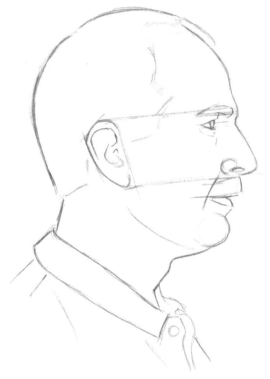

Step 4 In a profile view, the hairline is important to achieving a likeness, as it affects the size and shape of the forehead. This subject has a very high forehead, so the hairline starts near the vertical centerline of the cranial mass. Once you're happy with the shapes of the face and hairline, start refining the features to give them form.

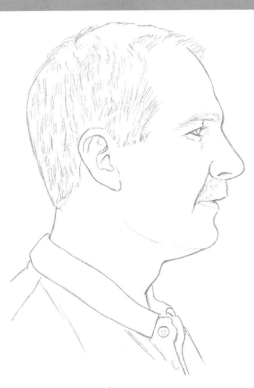

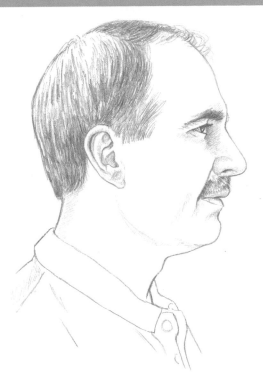

Step 5 Here you can see that the drawing is really starting to resemble the subject. Next switch to a 2B pencil and continue building up the forms. Round out the nose and chin; add light, soft strokes to the area above the lip for the mustache; and suggest the hair using short, quick strokes. Then add more detail to the eye and develop the ear and the eyebrow

Step 6 Still using the 2B, continue to develop the hair, eyebrows, and mustache, always stroking in the direction that the hair grows. Leave plenty of white areas in the hair to create the illusion of individual strands. Next begin to suggest the curves and shadows of the face by shading the eye, ear, and nose.

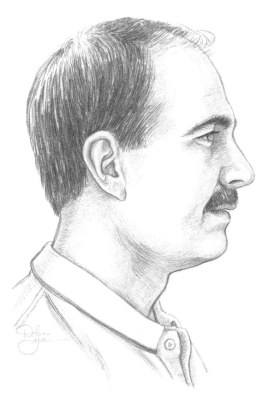

Step 7 Continue shading the head and face to develop form. Note that the light source is coming from above, angling toward the visible side of the face. This creates strong highlights on the crown of the head, cheek, and forehead, which you can leave free of tone.

Capturing a Likeness

Once you've practiced drawing the individual features, you're ready to combine them in a full portrait. Use your understanding of the basics of proportion to block in the head and place the features. Study your subject carefully to see how his or her facial proportions differ from the "average"; capturing these subtle differences will help you achieve a better likeness to your subject.

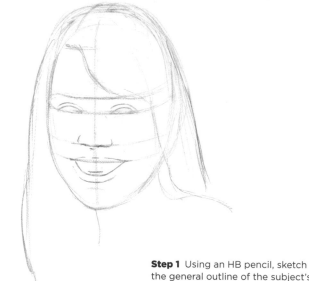

Step 1 Using an HB pencil, sketch the general outline of the subject's face. Then place the facial guidelines before blocking in the eyes, nose, and mouth. (Notice that the mouth takes up about one-quarter of the face.) Block in the shape of her hair, including the bangs.

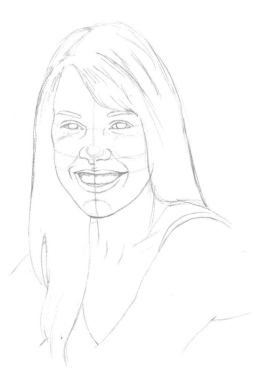

Step 2 Switching to a 2B pencil, indicate the roundness of the facial features. Compare your sketch to the photograph often, making sure that you've captured what makes this individual unique, like the turned-up nose, slightly asymmetrical eyes, and wide smile.

Step 3 Erase your guidelines, and then begin shading, following the form of the face with the 2B pencil and softly blending to create the smoothness of the skin. Next create the teeth, lightly indicating the separations with incomplete lines. Then switch to a 3B pencil to lay in more dark streaks of hair.

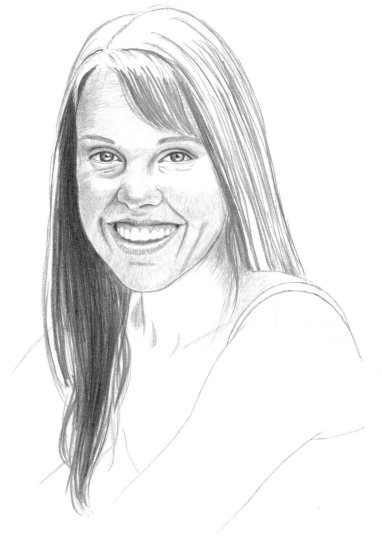

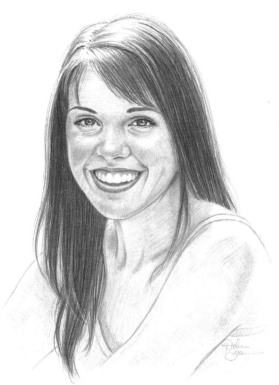

Step 4 To render the smooth, shiny hair, I use a 4B to lay in darker values. Vary the length of the strokes, pulling some strokes into the areas at the top of her head that have been left white for highlights to produce a gradual transition from light to dark. Then refine the eyes and mouth by adding darker layers of shading.

Working with Lighting

Whether you're drawing from a photo or from life, lighting is extremely important to the overall feeling of your portrait. Lighting can influence the mood or atmosphere of your drawing—intense lighting creates drama, whereas soft lighting produces a more tranquil feeling. Lighting also can affect shadows, creating stronger contrasts between light and dark values. Remember that the lightest highlights will be in the direct path of your light source and the darkest shadows will be opposite the light source.

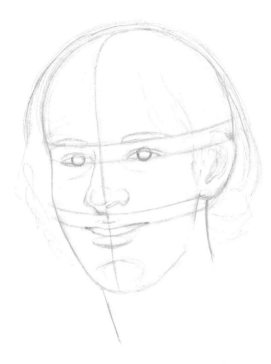

Step 1 Sketch the basic shape of the head, neck, and hair with an HB pencil. This subject's head is turned in a three-quarter view, so curve the guidelines around the face accordingly. Then lightly sketch the facial features, indicating the roundness of the nose and the chin.

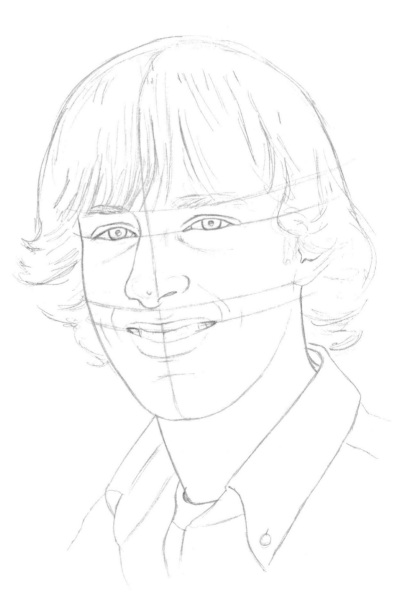

Step 2 Switching to a 2B pencil, define the features and fill in the eyebrows. Sketch a few creases near the mouth and around the eyes. Then add the collar, button, and neckband to his shirt.

Step 3 Using a 2B and frequently referring to the photograph, shade the right side of the face: First apply a layer of light, short strokes; then go back and apply a layer of longer strokes, still maintaining a light touch. To shade the hair, leave several white areas to indicate that the light is shining through it. Apply long strokes, staggering them at the top of the head to produce an uneven, more realistic shape.

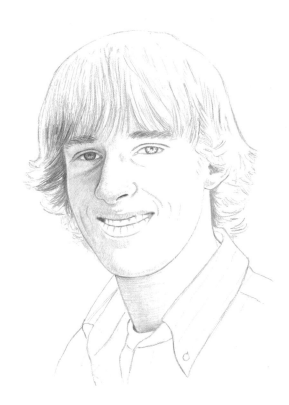

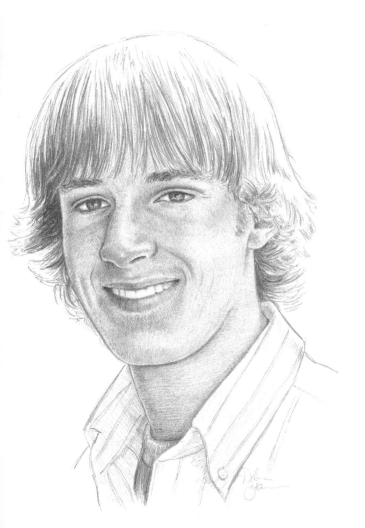

Step 4 Still using a 2B pencil, continue shading the face, keeping the left side a bit lighter in value to show that the light source is coming from the subject's left. Refine the left eye, leaving the right eye more in shadow. Shade the neck, again making his right side a bit darker. Then add more definition to the hair, leaving some white space around the edges to suggest the light shining through the hair.

Drawing from Life

Having models pose for you as you draw—or life drawing—is an excellent way to practice rendering faces. When drawing from life, you usually have control over the way your models are lit. If you're indoors, you can position the light source to your liking; if you're outdoors, you can reposition your model until you're satisfied.

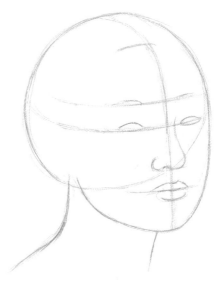

Step 1 First place the basic shape of the head with an HB pencil. This subject's head is tilted at a three-quarter angle, so shift the vertical centerline to the right a bit. Use your guidelines to block in the eyes, nose, and mouth. Then indicate the neck.

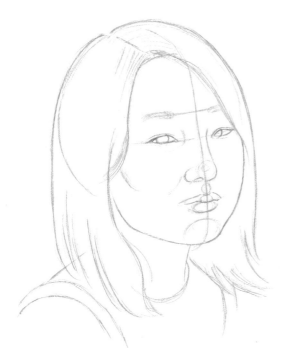

Step 2 Use the same HB pencil to foreshorten the subject's left eye, making it a little smaller than the right eye. Draw only one nostril, and make the mouth smaller on the left side. Making closer elements larger shows that the face is angled toward the viewer.

Step 3 Check the proportions of the drawing and finalize the placement of the features. Begin to develop the eyes, nose, mouth, and eyebrows. Take note of what your model is wearing (her necklace and the ruffled shirt), and begin to render the details accurately.

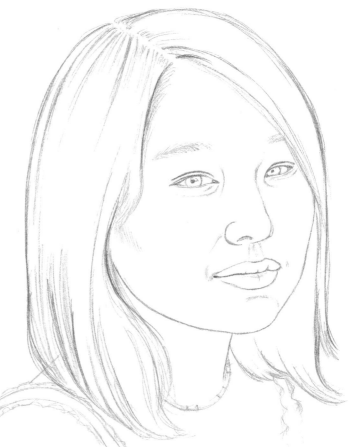

Step 4 Start shading the face in the darkest areas. Use a 2B pencil to develop the hair, varying the length of your strokes and leaving some areas mostly white for highlights. Then shade the neck using light, horizontal strokes.

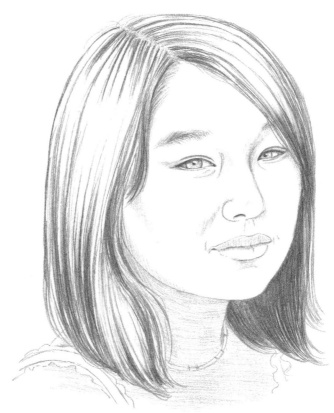

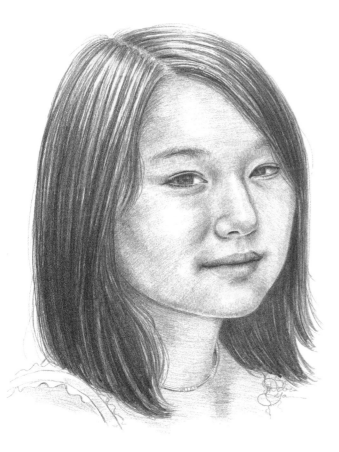

Step 5 Use a 3B pencil to add even darker values to the hair, leaving the lightest areas at the top of her head to show that the light is coming directly from above. Then locate the lightest values in her face. Use a kneaded eraser to lift out some highlights and to soften any strokes that are too dark, smoothing out the skin.

Rendering a Baby

Drawing babies can be tricky because it's easy to unintentionally make them look older than they are. The face gets longer in proportion to the cranium with age, so the younger the child, the lower the eyes are on the face (and thus, the larger the forehead). In addition, babies' eyes are disproportionately large in comparison to the rest of their bodies, so draw them this way!

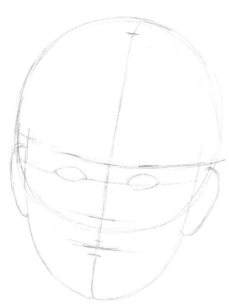

Step 1 Using an HB pencil, block in the cranial mass and the facial guidelines. The head is tilted downward and turned slightly to its left, so adjust the guidelines accordingly. Place the eyebrows at the horizontal centerline and the eyes in the lower half of the face.

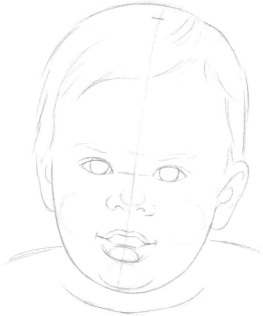

Step 2 Now create the fine hair using soft, short strokes and a B pencil. Draw the open mouth with the bottom lip resting against the chin. Then add large irises that take up most of the eyes and suggest the small nose. Draw a curved line under the chin to suggest chubbiness; then indicate the shoulders, omitting the neck.

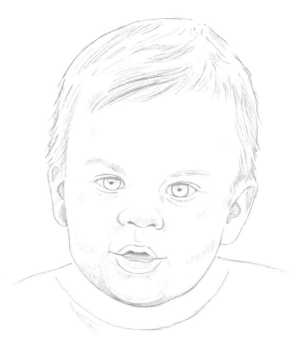

Step 3 Erasing guidelines as you draw, add pupils and highlights to the eyes with a B pencil. Lightly sketch more of the hair and eyebrows; then shade under the chin to give it form. Shade inside the ears. Then connect and refine the lips, shading the upturned corners to suggest the pudgy mouth. Shade the inside of the mouth, showing that there aren't any teeth, and then further define the neckline of the shirt.

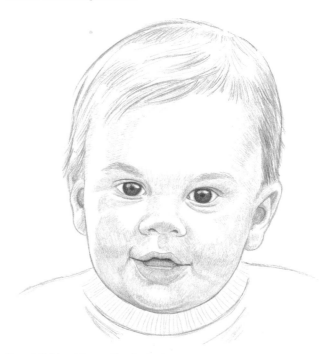

Step 4 With a 2B pencil, I shade the irises, and then go back in and lighten the highlights with a kneaded eraser. I draw more soft strokes in the hair and eyebrows and shade the lips and face. I emphasize the pudgy mouth by softly shading the smile lines, and then finally add curving lines to the neckline of the shirt.

Drawing a Baby's Features

Babies often have wide-eyed, curious expressions. Try curving the eyebrows upward to create the appearance of childlike curiosity; pull out highlights in each eye to add life and interest to your drawing. A baby's lips have a soft, pudgy appearance, and the mouth usually is not as wide as an adult's is. Adding highlights is important to convey a smooth texture, and creating creases at the corners of the mouth will help indicate youthful chubbiness.

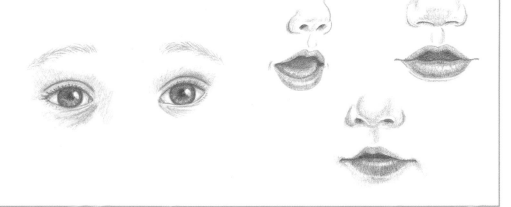

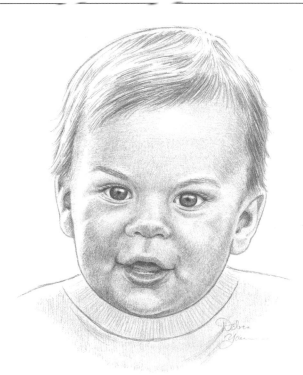

Step 5 Continue shading the face; then add another light layer of shading to the lips. Use the end of a kneaded eraser to pull out a highlight on the bottom lip. Then draw some very light eyelashes. Create darker values in the hair and eyebrows and round out the outline of the face. Lightly shade the shirt. Then take a step back from the portrait to assess whether you've properly built up the roundness in the cheeks, chin, eyes, nose, and mouth. Use a tortillon to softly blend transitions in your shading to make the complexion baby smooth.

Developing Hair

There are many different types and styles of hair—thick and thin; long and short; curly, straight, and wavy; and even braided! And because hair is often one of an individual's most distinguishing features, knowing how to render different types and textures is essential. When drawing hair, don't try to draw every strand; just create the overall impression and allow the viewer's eye and imagination to fill in the rest.

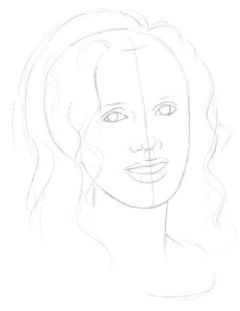

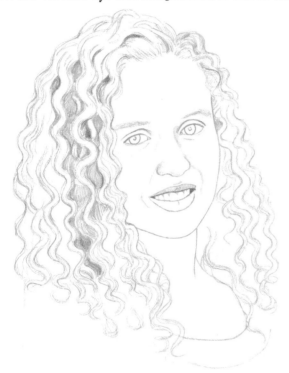

Step 1 Use an HB pencil to sketch the shape of the head and place the features. Then use loose strokes to block in the general outline of the hair. Starting at the part on the left side of the head, lightly draw the hair in the direction of growth on either side of the part. At this stage, merely indicate the shape of the hair; don't worry about the individual ringlets yet.

Step 2 Switching to a 2B pencil, start refining the eyes, eyebrows, nose, and mouth. Returning to the hair, lightly sketch in sections of ringlets, working from top to bottom. Start adding dark values underneath and behind certain sections of hair, creating contrast and depth. (See "Creating Ringlets" below.)

Creating Ringlets

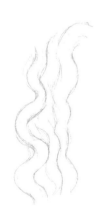 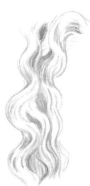

Step 1 First sketch the shapes of the ringlets using curved, S-shaped lines. Make sure that the ringlets are not too similar in shape; some are thick and some are thin.

Step 2 To give the ringlets form, squint your eyes to find the dark and light values. Leave the top of the ringlets (the hair closest to the head) lighter and add a bit more shading as you move down the strands, indicating that the light is coming from above.

Step 3 To create the darkest values underneath the hair, place the strokes closer together.

Step 4 Add even darker values, making sure that your transitions in value are smooth and that there are no abrupt changes in direction.

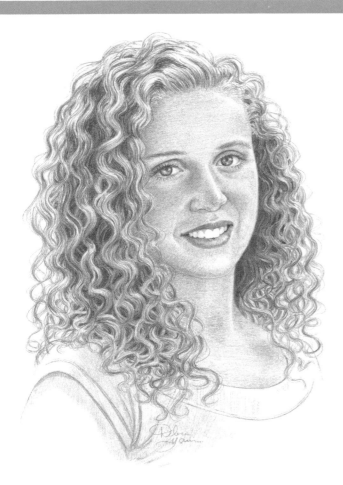

Step 3 Shade the face, neck, and chest using linear strokes that reach across the width of the body. Then define the eyes, lips, and teeth, and add her shoulder and the sleeve of her shirt. Next continue working in darker values within the ringlets, leaving some areas of hair white to suggest blond highlights. Although the hair is more detailed at this final stage, focus on simply indicating the general mass, allowing the viewer's eye to complete the scene. To finish, draw some loose strands along the edges of the hair, leaving the lightest values at the top of the subject's head.

Creating Facial Hair

Facial hair is another characteristic that distinguishes one individual from the next. Short, dark strokes are perfect for rendering a thick, coarse beard, whereas light, sweeping strokes are ideal for depicting a wispy mustache. Experiment with variations of light and dark lines when drawing a "salt-and-pepper" beard, and use a series of quick, short lines when indicating stubble.

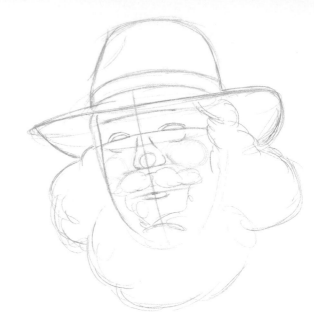

Step 1 First sketch the shape of the face with an HB pencil. Then place the guidelines and the features. Next draw the hat, including the band. Block in the masses of the hair, mustache, and beard with loose, curved lines. Just as when drawing any other type of hair, simply indicate the general shapes at this stage.

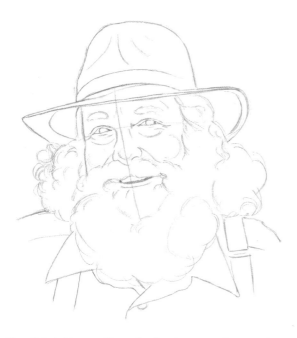

Step 2 Switching to a 2B pencil, refine the eyes, eyebrows, and teeth. Add wrinkles around the eyes and on the forehead; then build up the hat, sketch the shirt collar, and draw the suspenders. Now return to the hair, indicating the curls with circular strokes. Working from top to bottom, fill out the top of the hair, and then develop the mustache, which partially covers the mouth.

Focusing on Beards

When drawing a white beard, such as this one, group several lines together to create form, but leave some areas white. Also try drawing the strokes in varying directions—this adds interest and movement. It's also a good idea to overlap your shading a bit where the skin meets the hair, indicating that the skin is showing through the beard.

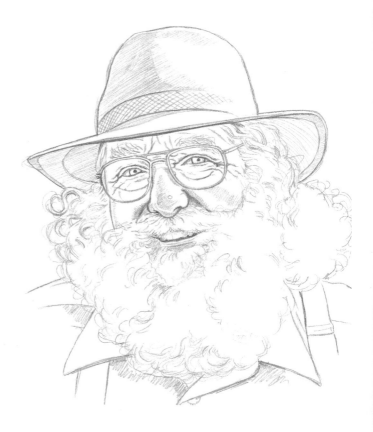

Step 3 Erase your guidelines and define the eyes and glasses. Shade the hat with a crosshatched pattern on the band. I begin rendering the short, tight curls of the beard and the mustache. Then add darker values to the curls on the left side of the face to separate them and to show the cast shadow of the hat.

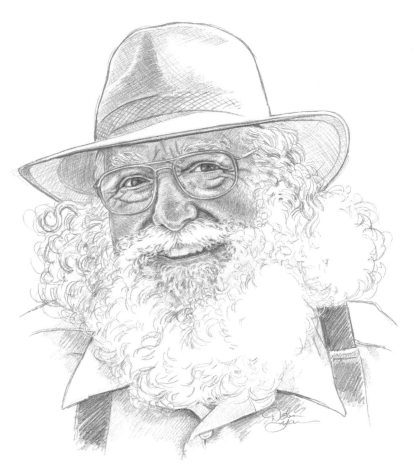

Step 4 Add a layer of shading to the irises, leaving white highlights in each eye. Using the edge of a kneaded eraser, pull out a highlight on each lens of the glasses to show the reflected light. Apply more shading to the hat to give it more of a three-dimensional look; then shade the suspenders and the shirt. Finish the curls in the hair and beard, varying strokes between tight, curved lines and quick, straight lines. Create the shortest, most defined lines in the mustache and around the mouth, leaving most of the beard to the viewer's imagination.

Still Life
Rose with Waterdrops

With its many petals and overlapping forms, the rose is often thought of as a difficult subject for beginners. But, like any other object, a rose can be developed step by step from its most basic shapes.

Step 1 Establish guidelines by using an HB pencil to block in the overall shapes of the rose and petal. Make these lines light so you won't have trouble removing or covering them later.

Step 2 Continue building the flower using a series of angular lines to delineate the petals.

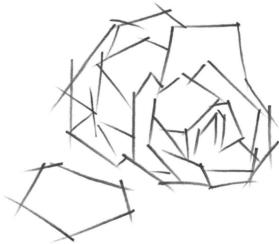

Step 3 As you develop the interior of the flower, make sure your strokes follow the angles of the petal edges.

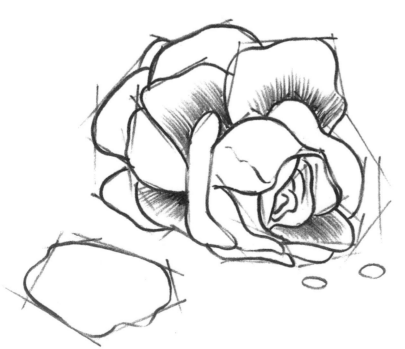

Step 4 Now shade from the inside toward the outer edge of each petal, tapering the end of each stroke.

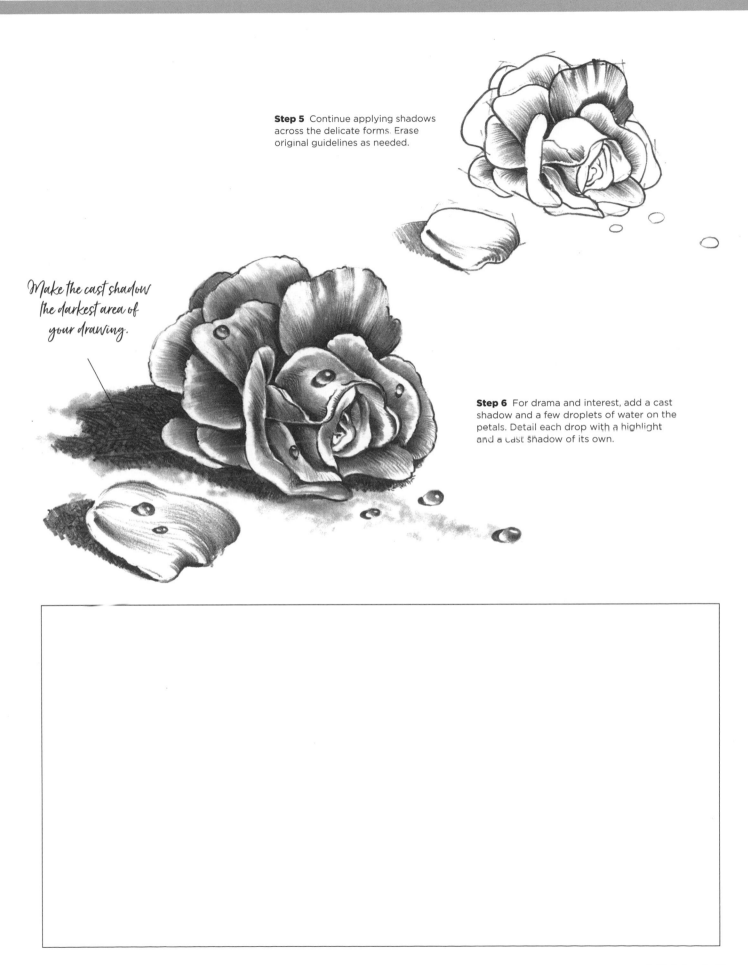

Step 5 Continue applying shadows across the delicate forms. Erase original guidelines as needed.

Make the cast shadow the darkest area of your drawing.

Step 6 For drama and interest, add a cast shadow and a few droplets of water on the petals. Detail each drop with a highlight and a cast shadow of its own.

Depicting Textures

One of the best ways to learn how to create different textures is to draw a still life of objects you have at home. Gather items with a variety of different textures, and arrange them in a dynamic composition. For this project, the subjects are food, glass, silver, wood, fabric, and liquid. As you follow the steps on these pages, refer to the detailed enlargements below to better see the highlights and individual pencil strokes.

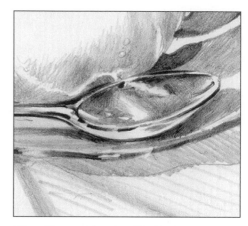

Crumbly Scone Make long, straight strokes with an HB pencil for the smooth portion of the scone, and draw short, hatched strokes of different values and in different directions for the rough edge and broken portion. For the darker, more solid masses of currants within the scone, use a 2B pencil.

Glass The best way to indicate the texture or surface of clear glass is to not draw it all—only suggest selected light and dark portions. Use the point and side of an HB pencil for this smooth surface and vary the values slightly. Notice that the glass also distorts the elliptical surface of the liquid at the left edge of the glass.

Silver The carefully placed highlights are the most important part of creating the illusion of metal. Notice that the shiny spoon absorbs dark areas and reflects light onto the side of the coffee cup. Use an HB pencil for the mid-tone areas and smooth them with a blending stump. Next use a 2B pencil to build up the darks.

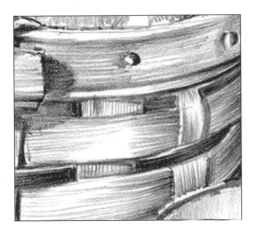

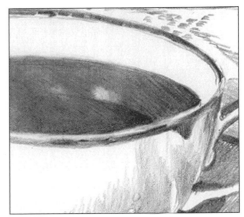

Basket To mimic the texture of the basket, use a sharp HB pencil and made vertical strokes for the vertical weave and horizontal strokes for the horizontal weave. Begin the strokes at the end of a segment and work toward the middle, pressing firmly at the beginning of each stroke and lifting the pencil at the end.

Fabric Use a series of short, directional strokes with the blunt point of an HB pencil to make the small, dense weave of the cloth. Apply the same strokes in the cast shadow, but make them darker and place them closer together. For the flower pattern, vary the pressure on your pencil and the density of your strokes to duplicate the design.

Liquid The coffee is dark, but its surface reflects the light from the side of the cup. Notice that there are several areas of value changes within the dark coffee as well. After establishing the darks in the coffee and the middle and light values in the cup, use a kneaded eraser to pull out highlights on the coffee surface.

Floral Arrangement

Floral arrangements are an ideal subject for experimenting with strokes and blends, as they feature a range of textures—from smooth, grooved leaves and lacy foliage to soft shadows. Liven up this simple triangular-shaped composition with a variety of strokes. Avoid overworking the drawing to keep it feeling loose and fresh.

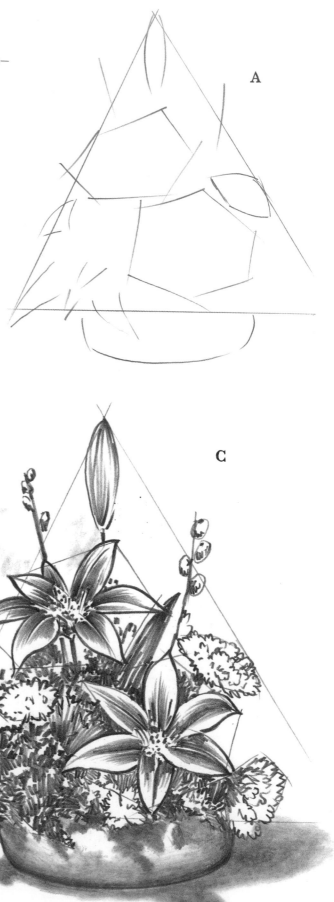

A

B

This rendering was finished using a loose, sketchy technique. Sometimes this type of final can be more pleasing than a highly detailed one.

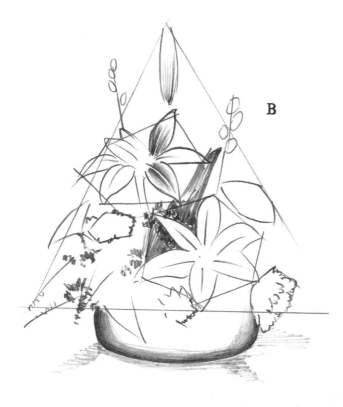

C

Liquid & Glass

This drawing involves more planning than the previous ones. It was done on Bristol board with a plate (smooth) finish. Use an HB pencil for most of the work and a 2B for the dark shadows. A flat sketch pencil is good for creating the background texture.

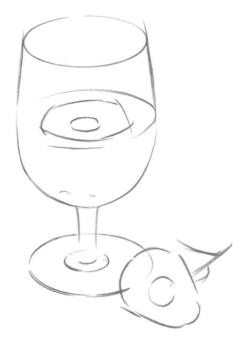

Step 1 Sketch the basic shapes of the glass, liquid, and flowers.

Step 2 Add more details, and begin shading the glass and liquid areas. Take your time, and try to make the edges clean.

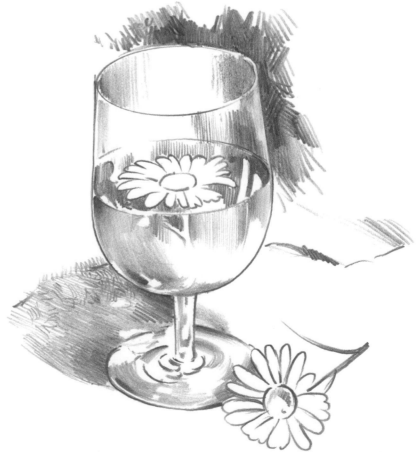

Step 3 Use the flat lead of a sketching pencil for the background, making the background darker than the cast shadows. Note the pattern of lights and darks that can be found in the cast shadow.

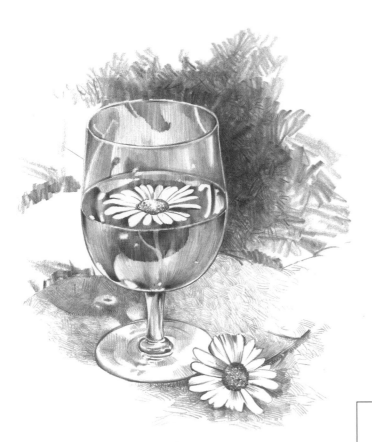

Step 4 Once you've completed the steps, use the finished drawing as your guide for finalizing lights and shadows. If pencil smudges accidentally get in the highlights, clean them out with a kneaded eraser. Lastly, use sharp HB and 2B pencils to add fine details.

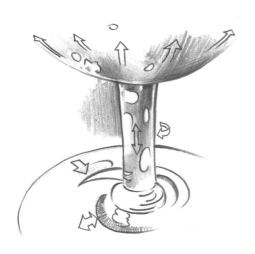

Shading

Use the arrows at right as a guide for shading. Remember to keep the paper clean where you want highlights. Highlights help suggest light coming through the glass stem, creating a transparent look.

Sunday Breakfast

As you follow the steps below, refer to the detailed enlargements on pages 102 and 103 to better see the highlights and individual pencil strokes.

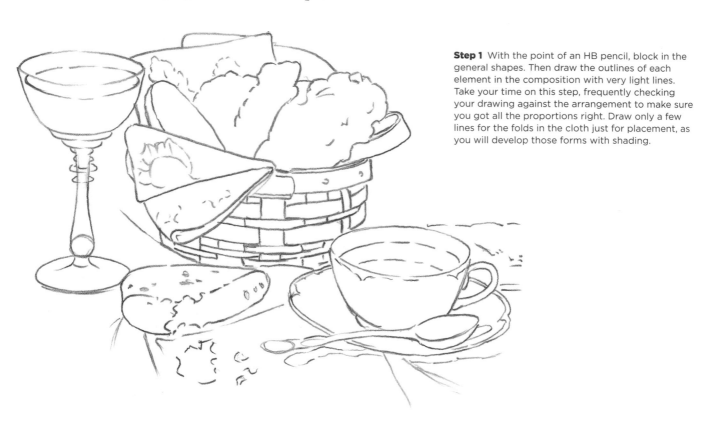

Step 1 With the point of an HB pencil, block in the general shapes. Then draw the outlines of each element in the composition with very light lines. Take your time on this step, frequently checking your drawing against the arrangement to make sure you got all the proportions right. Draw only a few lines for the folds in the cloth just for placement, as you will develop those forms with shading.

Step 2 When you are satisfied with the basic outlined shapes, begin building up their forms with various techniques (see details on pages 102–103). Start with an HB pencil for the light values, and then switch to a 2B and a 4B for the darkest accents. Rather than lay in and build up the values for the whole composition at once, work on one area at a time.

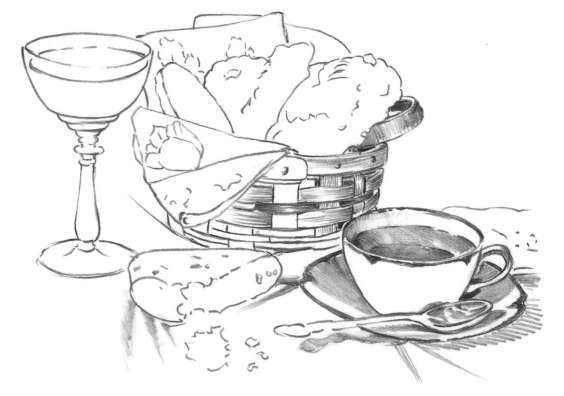

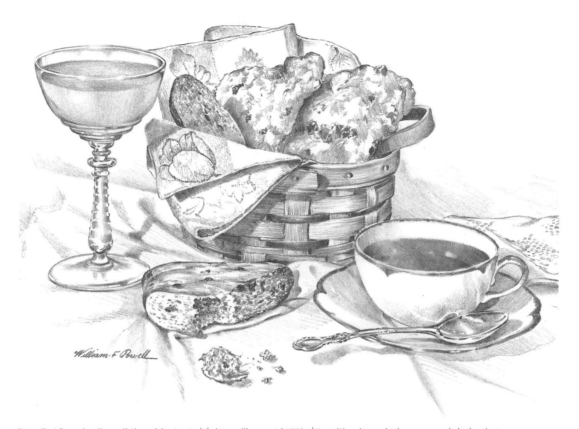

Step 3 After shading all the objects, finish by pulling out highlights with a kneaded eraser and darkening accents with sharply pointed 2B and 4B pencils.

Reflections & Lace

The shiny surface of a highly polished silver creamer is perfect for learning to render reflective surfaces. For this exercise, use plate-finish Bristol board, HB and 2B pencils, and a kneaded eraser molded into a point.

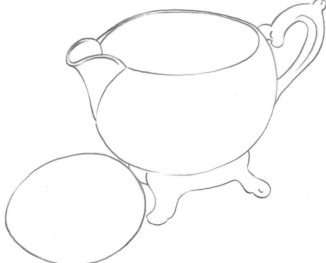

Step 1 Begin by lightly blocking in the basic shapes of the egg and the creamer. Don't go on to the next step until you're happy with the shapes and the composition.

Step 2 Once the two central items are in place, establish the area for the lace, and add light shading to the table surface. Next position the reflection of the lace and egg on the creamer's surface. Begin lightly shading the inside and outside surfaces of the creamer, keeping in mind that the inside is not as reflective or shiny. Then start lightly shading the eggshell.

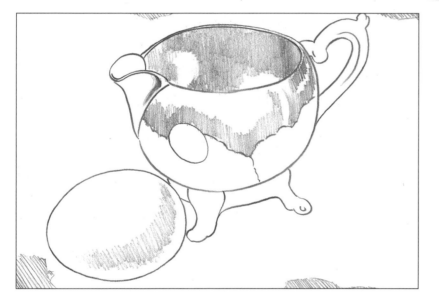

Step 3 At this stage, smooth the shading on the egg and creamer with a paper stump. Then study how the holes in the lace change where the lace wrinkles and then settles back into a flat pattern. Begin drawing the lace pattern.

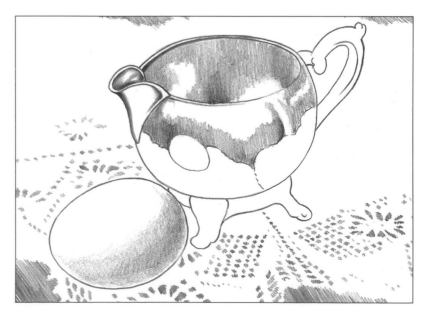

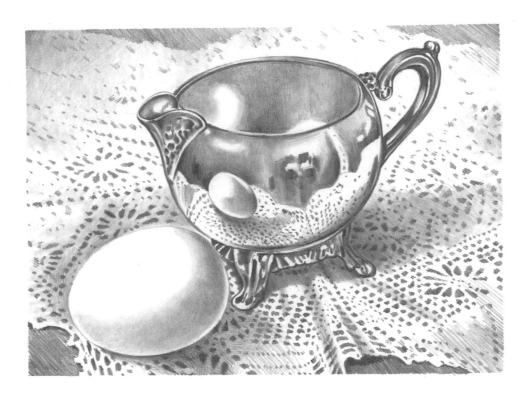

Step 4 In this final drawing, pay close attention to the reflected images because they are key to successfully rendering objects. Interestingly the egg's position in the reflection is completely different than its actual position on the table because in the reflection we see the back side of the egg.

Brimming with creative inspiration, how-to projects, and useful information to enrich your everyday life, quarto.com is a favorite destination for those pursuing their interests and passions.

© 2023 Quarto Publishing Group USA Inc.

Artwork on back cover (horse) © Michele Maltseff; front cover (tree) and pages 1, 2, 3, 8-9, 12-17, 32, 33 (top), 34-35, 38-45, 46-47, 64-67, 100-112 © 1989, 2001, 2003, 2004, 2005, 2009 William F. Powell; pages 4, 18-23, 24-31, 48-51, 62-63, 68-69, 76-77 © 1950, 1989, 1997, 1998, 2001, 2003, 2004, 2008 Walter Foster Publishing, Inc.; pages 5, 6, 7 © 1997, 2003, 2006 Diane Cardaci; pages 10-11, 33 (bottom) © 1999, 2003, 2005, 2009 Michael Butkus; pages 36-37, 52-53 © 2007 Christopher Speakman; pages 54, 55 © 2008 Linda Weil; pages 56-57, 60 (bottom), 70-71, 72-75 © 1989, 1998, 2003, 2005, 2009 Mia Tavonatti; pages 58-59, 60-61 © 1989, 1997, 1998, 2003, 2009 Walter T. Foster; and pages 78-99 © 2006, 2007, 2009 Debra Kauffmann Yaun.

First published in 2023 by Walter Foster Publishing, an imprint of The Quarto Group.
100 Cummings Center, Suite 265D, Beverly, MA 01915, USA.
T (978) 282-9590 **F** (978) 283-2742 **www.quarto.com** • **www.walterfoster.com**

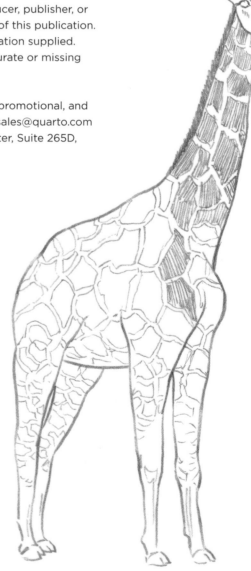

All rights reserved. No part of this book may be reproduced in any form without written permission of the copyright owners. All images in this book have been reproduced with the knowledge and prior consent of the artists concerned, and no responsibility is accepted by producer, publisher, or printer for any infringement of copyright or otherwise, arising from the contents of this publication. Every effort has been made to ensure that credits accurately comply with information supplied. We apologize for any inaccuracies that may have occurred and will resolve inaccurate or missing information in a subsequent reprinting of the book.

Walter Foster Publishing titles are also available at discount for retail, wholesale, promotional, and bulk purchase. For details, contact the Special Sales Manager by email at specialsales@quarto.com or by mail at The Quarto Group, Attn: Special Sales Manager, 100 Cummings Center, Suite 265D, Beverly, MA 01915, USA.

ISBN: 978-0-7603-8202-8

Cover design by Burge Agency
Copyedit by Elizabeth Gilbert
Proofread by Caitlin Fultz

Printed in China
10 9 8 7 6 5 4 3 2 1